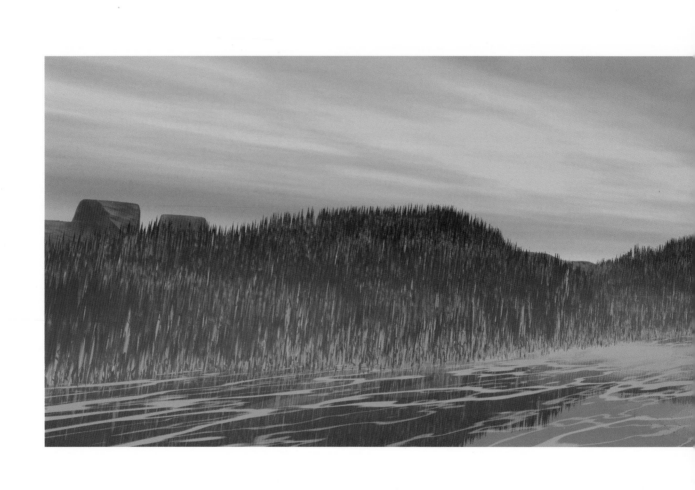

Going Digital

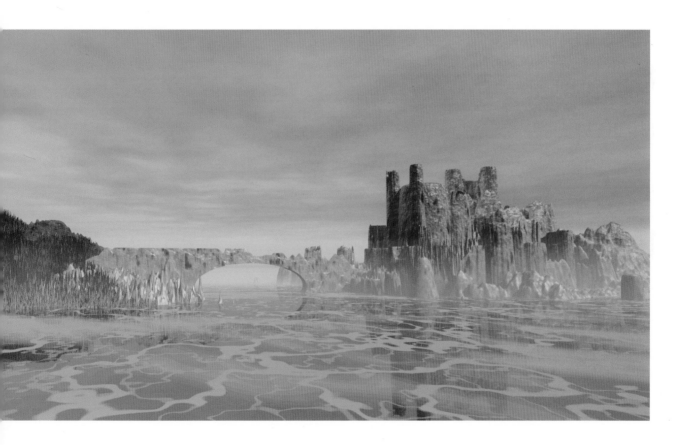

Acknowledgments

When I was in art school, I met a lot of students whose parents were dead set against their becoming artists. In contrast, my parents have always been enthusiastic supporters of my artistic ambitions, and my statement of gratitude has to begin with them.

I would also like to thank the following teachers whose words and inspiration I carry with me to this day: Joseph Pavone, Marlene Miller, Robert Schulz, Jack Faragasso, Michael Aviano and Jerry Allison.

Thanks to my Mac guru, Jim Yost, for all of his help—past, present and future.

And finally, to my extraordinary wife, whose own artistic talent helped shape this book, and whose patience and endurance insured its completion.

This book is dedicated to my family.
You know who you are!

Going Digital *by John Ennis*
Copyright ©1997 by MADISON SQUARE PRESS
All rights reserved. Copyright under International and Pan-American Copyright Conventions.

All artwork ©1997 by John Ennis unless otherwise noted.

ISBN 0-942604-50-4
Library of Congress Catalog Card Number 96-076800

Graphic Design by Jo-Ann Osnoe

Distributed to the trade in the United States & Canada:
WATSON-GUPTILL
1515 Broadway
New York, New York 10036

Distributed throughout the rest of the world by:
HEARST BOOKS INTERNATIONAL
1350 Avenue of the Americas
New York, New York 10019

Published by:
MADISON SQUARE PRESS
10 East 23rd Street
New York, New York 10010
Fax: (212) 979-2207, Phone: (212) 505-0950

Printed in Hong Kong

Going Digital
by John Ennis

AN ARTIST'S GUIDE
TO COMPUTER ILLUSTRATION

MADISON
SQUARE
PRESS

Contents

Section One:
How It's Done 13

An introduction to the fundamental basics of digital illustration, this section explains how an artist's traditional tools, such as brushes and color palettes, work in the digital medium.

Section Two:
How It's Applied 27

An under-the-hood look at over twenty of the author's published book cover illustrations.

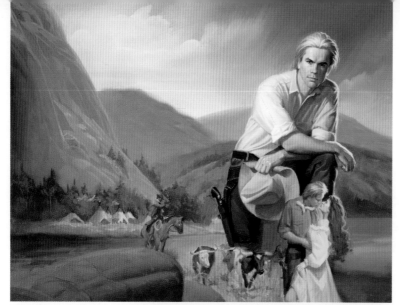

Iris, oil on masonite, 1994

Sea Mistress, oil on masonite, 1993

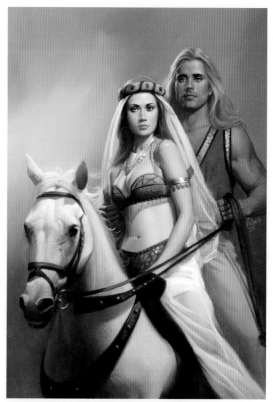

Pagan Bride, oil on masonite, 1994

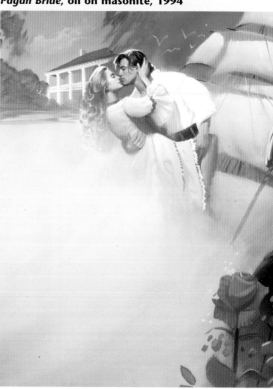

Raider's Lady, oil on masonite, 1992

◀ *Sweet Forever,* oil on masonite, 1991

About the Author

The work of illustrator John Ennis has graced the covers of literally hundreds of books. These illustrations have been published in over 26 countries and can be found in bookstores from Moscow to Singapore.

Mr. Ennis began painting in oil as early as the eighth grade, but his real skill began, as he describes it, with the intensive training he received at the Art Students League of New York in the late seventies. Here he had the opportunity to study figure painting with talented and skilled instructors, all of whom were products of the Reilly System, a method of teaching realism created by the late Frank J. Reilly.

His first book cover commission came while still a student, and during the course of his career, he has illustrated for every major paperback publisher in the U.S. A sampling of this work is shown here.

As these oil paintings suggest, Mr. Ennis is a traditional illustrator from the "old school." Throughout his career, oil paint remained his medium of choice. That is, until he discovered the world of digital painting.

It will become apparent, as you explore this book, that his successful transition into digital illustration is an embodiment of the knowledge gained from his earlier work, and the substantive power of this new medium. His traditional roots are still evident and have become a point of departure, if you will, for the limitless possibilities digital imaging offers.

Savage Pride, 1994, ▶
oil on masonite

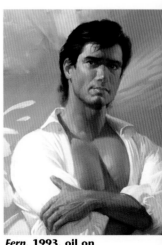

Fern, **1993, oil on masonite**

Introduction

Imagine yourself a scribe in a fifteenth century abbey famous for its illuminated manuscripts. One day, in strolls Johann Guttenberg with his new-fangled printing press. Do you burn him at the stake for heresy or embrace this ominous machine? After a lifetime of making my way with paint and brush, this was pretty much how I felt the first time I booted up my PowerMac.

In retrospect, that moment seems to have been a watershed for me. Only a year before I had scoffed at the notion of painting in a computer and yet here I was, making the same brushstrokes I had always made, but on a monitor instead of a canvas. And, as I began to explore the capabilities of this new medium, I became awestruck. Awestruck by the power. Awestruck by the possibilities. Each new discovery seemed to open doors that promised endless opportunity for creativity. This is not a medium that you can get your arms around, not something you will need to squeeze to get results. This is an ocean to be discovered, and I feel indeed fortunate to have taken the plunge.

This book was written to introduce you to computer illustration and to help get you started. As a medium, it is still relatively new and widely misunderstood. I hope the pages that follow will help illuminate for you what making art in the computer is all about and decide if going digital is right for you.

This is a great way to make art. And I have come to realize that my success with digital illustration is not due to the medium itself, but to the lifetime of artmaking experience that I was able to bring to it. The basic principles of art still apply, but applying them has become a lot more fun. Loads more fun! Better than ice cream.

How It's Done

Section One

PAINTING

The question most artists ask about digital illustration is how do you paint in a computer? Well, it's done with a brush! A digital brush like the one pictured below. Also called a pen or stylus, this instrument is a pointing device performing the same functions as your mouse, but with the familiarity and ease associated with a pen or pencil. Used in conjunction with a pressure sensitive tablet (fig. 1), whatever you draw on the graphics tablet appears on the screen. And since the tablet is pressure sensitive, the harder you press, the darker and wider the line.

But this is just the beginning! You can instruct this pen to act like an airbrush, a bristle brush, a sable or even a watercolor brush. Your stroke can have a hard or soft edge, or using an elliptical tip (fig. 4), change from thin to thick as you make a turn. You can instruct the brush to fade out after so many pixels (or inches). But best of all, you can undo! Undo your last brushstroke, and remake it as many times as you like until you get it right!

Fig. 1. Drawing with a digital stylus on a pressure sensitive graphics tablet. The stroke you create on the tablet appears on the monitor.

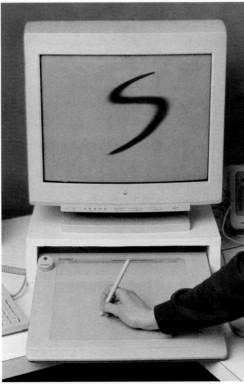

Fig. 1

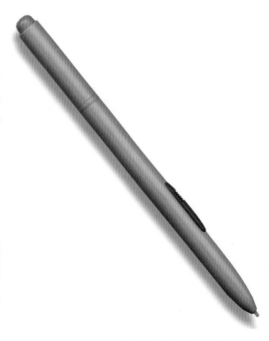

Fig. 2. The cordless digital stylus from Wacom Technology Corp.

BRUSHES

Fig. 4. The top row is a sample of how you will see some of Photoshop's brushes in the brushes palette. The black circle on the left represents the tip of a round brush with a hard edge. The middle circle is the same brush with a soft edge, like a sable brush. The ellipse on the right is a soft brush squeezed into the brush-tip shape of a flat brush. Below each brush tip is the brush's corresponding brush stroke.

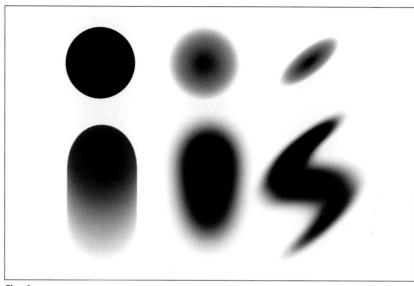

Fig. 4

Fig. 5. Brushstrokes applied with a few of Painter's brushes. From left, watercolor, chalk, felt tip, airbrush.

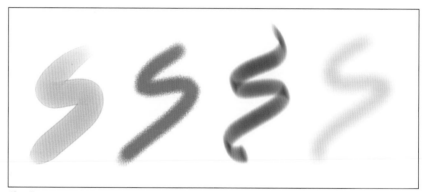

Fig. 5

Fractal Design's Painter program is designed specifically to imitate natural media (fig. 5). With this application, you can use the stylus as chalk, charcoal, oil pastels, magic marker—just about anything you may already be using in "real life." And you can mix all these media, or "looks," without the physical conflicts that their real-life counterparts would create. Painter provides textures that you can use to imitate familiar surfaces, like canvas or paper, but you can create and import your own, offering endless possibilities. In addition, there is no drying time to wait out, no brushes to clean, no spills to mop up, and no harmful chemicals waiting to be discovered by a curious toddler.

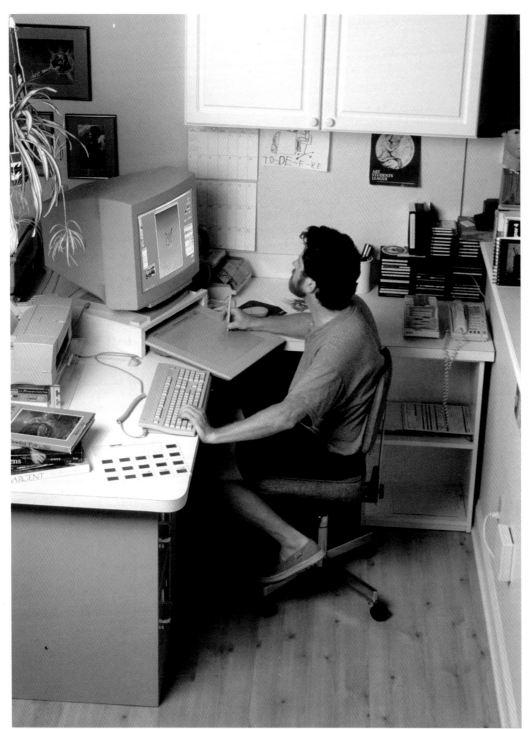

Fig. 3. The artist at work in his chemical-free digital studio.

Fig. 3

THE COLOR PALETTES

Apple Macintosh computers have a resident color palette (fig. 7) called the system palette. In addition, each painting program has its own way of presenting color, although some allow you to access the system palette. Shown below (figs. 8 & 9 respectively) are the palettes from Adobe Photoshop and Fractal Painter. They all offer the same thing—a seemingly limitless choice of colors. And all are based on the principles of hue, value and saturation. Which one you prefer is a matter of personal taste.

Fig. 7. The Apple color palette.

Fig. 9. Fractal Design Painter palette.

Fig. 8. Adobe Photoshop palette.

Using your mouse or stylus, you can simply pick a color you see from the palette or use sliding bars to custom mix your own. Since the color you see in your monitor is light-driven, you will need to learn (or relearn) the color light wheel (fig. 10), also referred to as additive color. It is important to understand, for example, that adding red to an image simultaneously subtracts cyan.

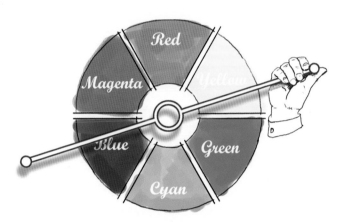

Fig. 10. The color light wheel. The complementary colors are different from the opaque color wheel.

In addition to mixing colors, there is another way to pick a color "on the fly" so to speak. Often I find myself picking a color out of the image I am working on and adjusting it. Look for the eyedropper tool in your program's tools palette. You can click anywhere in your painting with this tool to pick up a color you have already used. Once chosen, you can adjust the value of your new color up or down, increase or decrease the saturation, or change the hue. This can shave hours off the physical act of mixing paints in real life. Not to mention remixing a color you used yesterday.

When you have chosen a color, just click on the brush tool and start painting. And if you make a mistake, just use the *undo* command. The value of this simple feature cannot be overstated. I wish I could use this trick with real oil paint! And Painter gives you multiple layers of undo. You could lift off the last 32 brush strokes if needed.

THE FLEXIBILITY OF LAYERING

A common approach to realistic painting in natural media like oil paint is to start with the background and layer your way forward. This helps to make the foreground look like it is in front of the middleground, and the middleground look like it's in front of the background. You can approach making digital art the same way but without "commitment."

Photoshop and Painter are among the painting applications that offer a feature called layering. In the example below, each layer remains uncommitted to the others, and can be individually edited. For example, the horse and riders could be flopped, or using scaling tools, could be made bigger or smaller. The layers can be painted into or made partially transparent. The editing choices seem endless. And all this can be done and redone on any layer until you are perfectly satisfied with the result. When you are finished you will want to "flatten" the layers together for final output to a printer.

Fig. 11. An example of how layering was used to create the art (far right).

Before taking this step, I like to save the image in the floating layers form and file it under a separate name. This way I can go back to the layers file and make changes later if I need to. If you have ever done commercial illustration, you will know how valuable this can be. Changes to finished art are commonplace in the commercial world, and this feature minimizes the pain in changing the art after the fact, as well as greatly expanding your own flexibility in creating it.

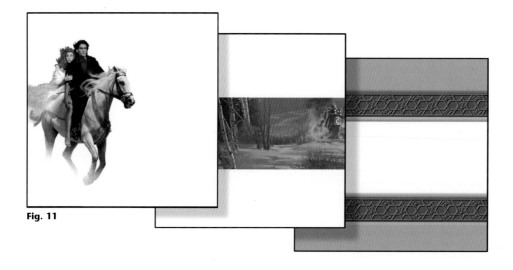

Fig. 11

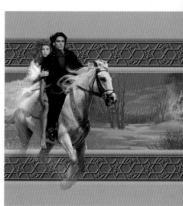

COLOR CORRECTING

The color of each layer of your work can be adjusted using a number of methods. Figure 12 is Photoshop's dialogue box for Hue/Saturation. This allows you to adjust the hue, saturation, or value of the entire layer. Or you could pick a particular hue and adjust only that if you choose to. These changes could be applied to a more specific area of the layer by using the selection tools to isolate a particular item, say a hat, and change its color in some way.

Fig. 12. Hue/Saturation, one of the many color adjusting tools offered in Photoshop.

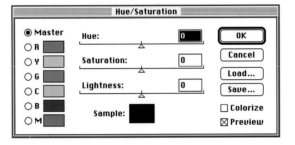

MASKING

Airbrush artists often like to mask off certain areas of their work to protect it from harm as they continue to paint.

The masking features in Painter and Photoshop add considerable capabilities to this approach. These masks can be hard edged, the kind you might make with a knife, or feathered or brushed to create any shape you like. The default color for the mask is red, a comfortable reminder of the real world masking material known as rubylith.

Fig. 13. An example of a mask created in Painter. The red area protects the canvas underneath, allowing you to paint in the white area only.

FILTERS

When a photographer places a filter over the lens, it is done to add an effect to the entire picture. In digital imaging, a filter performs a similar function, but the results can be extraordinary.

Photoshop comes with many filters and there are many more available on the market made by third-party software developers. These filters "plug in" to Photoshop and therefore are often referred to as plug-ins. Many of these filters can be used in Painter as well.

The variety of effects these filters can create would be impossible to describe here, but for the sake of explanation, the Gallery Effects filter Emboss has been used in figure 15 to offer a sample. This filter group is now included with Adobe Photoshop 4.0.

The before (fig. 14) and after (fig. 15) effect of applying the Gallery Effects filter Emboss.

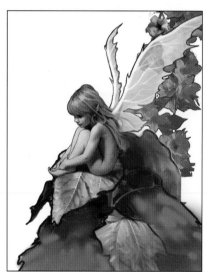 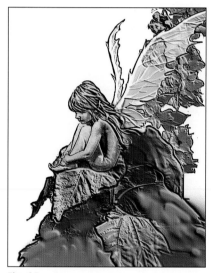

Fig. 14 **Fig. 15**

THE PEN TOOL

The purpose of this book is to offer a broad overview and as a result there are many tools and features not mentioned here. I felt, nevertheless, that a passing mention should be made of the pen tool.

The nearest real-life equivalent to this tool is a combination of an inking pen and the French curve. The pen tool is the mainstay of object-oriented programs like Adobe Illustrator and Macromedia Freehand. It is also included in the 2-D paint programs Photoshop and Painter.

It is essentially a mechanical drafting tool that allows you to easily draw the kind of beautifully curved lines that in the past would have required drafting skills with a ruling pen. However, the final result is no longer limited to an inked line.

Once the curve is created, it is called a path. This path can then be used to instruct any other tool, say the airbrush, to produce a soft stroke that precisely follows the curve (fig. 17).

A shape drawn with this tool can also be used as an outline, filled with a color, or used to isolate a particular area of the art.

Use of the pen tool will seem unfamiliar at first and may take some getting used to, but it is an essential tool and the learning curve is worth the trouble.

**Fig. 16.
A screen snapshot of Photoshop using the pen tool.**

Fig. 16

**Fig. 17.
Applying an airbrush stroke to the path created above by the pen tool.**

Fig. 17

THE 3-D WORLD

Fractal Design Corporation's Ray Dream Designer, Adobe Dimensions, and Specular's Infini-D are among the programs that are designed to create objects that exist in a virtual three-dimensional space.

Let's say you want to create a bridge for an illustration. In wireframe mode (fig. 1) you would begin building the various parts. Once complete, you could then rotate the bridge, or view it from any position. Shine a light on it or several lights if you wish. Assign a texture to it, one that comes with the program or one that you create. When all this is done, move your virtual camera around the scene until you find a view you like, and instruct the program to render that view. Depending on the size of that scene, this rendering could take ten minutes or ten hours.

Bryce from Metatools is a 3-D landscape application. Instead of objects, you will be creating wireframe mountains, oceans, skies, even other planets if you like. After choosing the position of the sun, you will render the scene. Bryce has a unique and inviting interface that is relatively easy to learn and the results can be intoxicating.

Be forewarned that this 3-D stuff is complicated. And for an artist used to working in two dimensions, it requires an adjustment in the thought process to incorporate the added dimension.

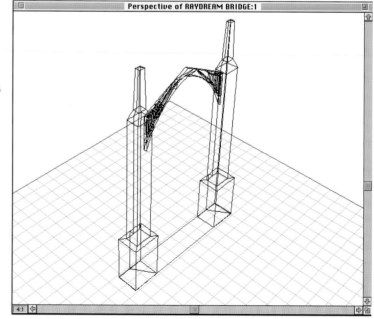

Fig. 1. A section of a bridge viewed in Ray Dream Designer's wireframe mode.

Fig. 1

IMPORTING AND EXPORTING

There are lots of ways to make art in the computer. You can paint from scratch the same as you would on a blank canvas. Or try "importing" a photo or a drawing and paint over it. To do this, take a slide or a drawing to a service bureau and have them scan it onto a floppy disk or other form of removable media. Or consider buying a flatbed or slide/negative scanner for your studio.

Let's say that you have made a beautiful pen-and-ink drawing that you would like to add color to. Place it on your flatbed scanner, import it into a paint program in your computer and wash color over it. You can play around with the color until it is just right without ever affecting the original. If your art is bigger than your flatbed scanner, scan it in sections or have a transparency made of it and have that scanned instead.

You can also use your flatbed scanner to import textures and materials like leather, handmade paper, wood, fabrics—anything flat that fits. The limitation here is that you have no control over the light source.

Once your digital artwork is complete, you will probably want to "export it," that is, get it out of the computer. This output device could be an inexpensive inkjet printer plugged into your computer, or a big Heidelberg press at a commercial printer, or lots of things in between. Some artists create some of the work digitally and have it printed on canvas, watercolor paper or other surface material and continue the work outside the computer. Of course, only certain printers will accept materials of this nature. You can also output to transparency film.

Look for a service bureau in your area. Service bureaus are companies, often small companies, who service the digital graphics industry. They usually carry the more expensive outputting devices that mere mortals can't afford. To find one, try the computer section of the business yellow pages or ask a friend in the industry.

As a professional illustrator, you will deliver your work to the client on some form of portable disk. For more info on this, see Section Four: Getting Started.

How It's Applied

Section Two

Etching in Stone

The digital illustration below was a first not just for me, but for the art director as well. I had been experimenting with the computer for a few months, and suggested that the book cover for this medieval story be done digitally. I guaranteed the project by offering to repaint the art in oil if something went wrong. For his part, this forward-thinking art director suggested that I create an illustration that takes particular advantage of the computer's capabilities.

I have always liked the look of motifs in art, but creating repetitive shapes in oil paint had often proved laborious. Digital imaging could make this task much easier.

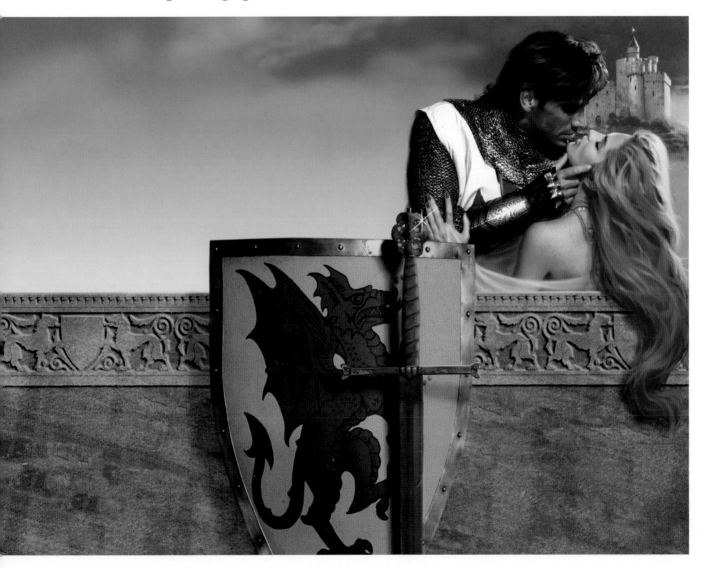

Fig.1. Photo of quarry stone.

Fig. 2. Cloned several times to create a flat wall, the color of the image above was then adjusted in Photoshop.

Fig. 3. Created in Photoshop from a medieval heraldic design, this image was then flopped and cloned repeatedly to make an extended motif.

After photographing stone samples at a nearby quarry (fig. 1), I scanned the slide into the computer and used the cloning tool in Adobe Photoshop to extend it and turn it into a flat wall (fig. 2).

Using the drawing tools in Photoshop to make the medieval motif in figure 3, I was able to give this design a three-dimensional look by applying the "emboss" filter (fig. 4).

This filter creates the illusion of relief by adding a top (highlight) plane and a bottom (shadow) plane. Anyone who has ever used an airbrush will appreciate the masking abilities that these painting programs offer. Photoshop's editing features allowed me to separate the highlight, shadow and front planes of the now embossed heraldry, creating separate masks for each one (figs. 5, 6 & 7). The default color for these masks is red, but could be changed to any color. By floating the highlight mask (fig. 5) over the flat stone wall, I was able to "chisel out" the motif's top edge by raising the value of the wall just in this area. The rest of the wall was protected by the red part of the mask.

Similarly, the etched shadows were created by laying the shadow mask (fig. 6) over the same wall and lowering the value of the areas not protected by red.

Finally, I used the mask in figure 7 to slightly raise the value of the front plane of the heraldry in order to separate it from the rest of the wall.

If this all sounds complicated, well, it is. The whole digital experience is complicated! I was learning on the job when I created this, so the process of making this etched motif took a day or two. But having learned it, I could now create a similar look in a snap.

Fig. 4

Fig. 4. Applying Photoshop's emboss filter to the now extended black and white motif produced this greyscale embossing. This was then used as a basis to create separate masks (shown below) for the highlight, shadow and front planes of the embossed motif.

Fig. 5

Fig. 5. The highlight mask, used to selectively raise the value of the wall in order to create the top edge of the stone motif.

Fig. 6

Fig. 6. The shadow mask, similarly used to lower the value of the wall where the shadows of the carved shapes would fall.

Fig. 7

Fig. 7. The front plane mask, used to create a subtle difference in value between the front plane of the heraldry and the front plane of the wall.

Layering in Photoshop

"The Night Before Christmas" is an anthology of short Christmas stories, and although the subject is simple enough, making the cover art became complex.

Adobe Illustrator is a graphics application that lends itself to more mechanically drawn shapes. It was here that the outlines for the banner and oval for this book cover were initially created. These elements were imported into Photoshop and became the compositional base for the rest of the illustration.

The elements of this cover were each given their own layer so each could be independently manipulated. This allows each item to be moved, resized, flopped, painted, colorized—in short, edited—without affecting the other layers. Below is a snapshot of how the monitor displayed this working illustration with the layers palette open. The layers are displayed individually on the following pages.

Please remember that even though they are all independent for the purposes of editing, they appear on the screen as a

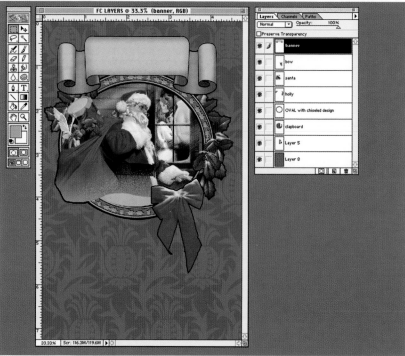

Fig. 1

Fig. 1. A screen snapshot of the Photoshop image with the layers palette displayed.

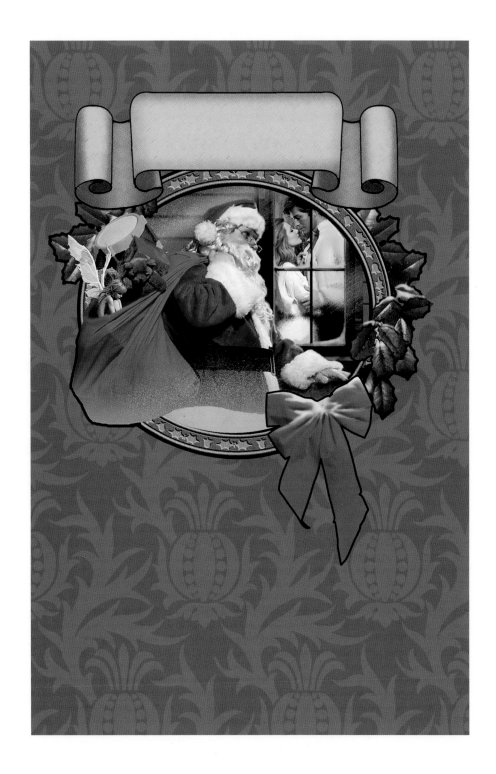

Figs. 2-9. Reading from left to right, the layers used in creating "The Night Before Christmas," the banner being the topmost layer.

Fig. 2

Fig. 3

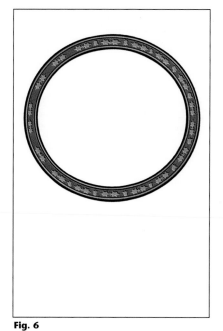

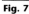

Fig. 6

Fig. 7

single composite. This gives the artist unlimited freedom in making design decisions before committing oneself to the final composition. Perhaps the background would work better as a different color? Maybe the banner should be 10% larger. Would the work be improved if the bow was flopped and placed on the opposite side? These changes can be made in a matter of minutes, and if you are unhappy with the result, you can

Fig. 4

Fig. 5

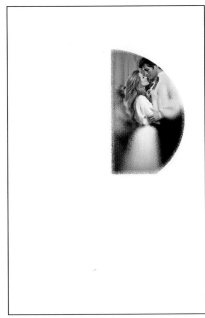

Fig. 8

Fig. 9

always return to the previous version. Photoshop's layers can be turned on or off individually. Their order can be easily rearranged. For example, the banner could be placed behind the oval, instead of in front. As you can see, this ability allows for a great deal of flexibility not only in creating the art, but in making changes after the fact, as any experienced illustrator can appreciate.

Using Filters in Photoshop

The art director was looking for a pop-art look to set the mood for "Brand New Cherry Flavor," described to me as a hard-core, hard-rock, Hollywood thriller.

Saving this "mood" problem for last, I illustrated the entire image and gave the face a traditional oil-painted look (fig. 1). The file was saved at this stage.

Real world oil painting, like other natural media, is a linear process. You begin with the background, end with the foreground, and the layers in between are permanently sandwiched together. Digital painting is more like the growth of a tree. At any given stage, the current version can be saved, and different versions can branch out to end up with several alternative solutions to the same problem. "Brand New Cherry Flavor" is a good example of how this system works.

Experimenting with the face required that it be isolated from the other elements. The face in figure 1 was therefore cut and pasted onto a separate layer. The lips had been given a "cherry flavor" color to reflect the book's title, and I needed to isolate them as well, so they were copied to yet another layer. I then began using filters to affect the face, knowing later I would paste the original lips back on. Figures 2, 3, and 4 were accomplished by applying combinations of Adobe's Gallery Effects filters, specifically Watercolor, Find Edges, Stained Glass, and Sponge. Figures 5, 6, and 7 were done with the help of Kai's Power Tools Texture Explorer. Both of these filter groups are Photoshop plug-ins, that is, they are "plugged into" the

application, hence the name. Gallery Effects filters are now included with version 4.0 of Photoshop.

After presenting all six solutions to the art director, the psychedelic version in figure 7 was chosen. Using the airbrush tool to mask out the hard edges around the neck, the face was blended into the white background for the final result.

Fig. 1

Fig. 1. The illustration (above) was brought to this stage before applying any filters. The face was kept on a separate layer from the other elements.

Figs. 2, 3, & 4. These images were created by applying combinations of Gallery Effects filters. These filters are now part of the Photoshop 4.0 package.

Figs. 5, 6, & 7. These three faces are wildly different from each other, yet share a similarity peculiar to Kai's Power Tools.

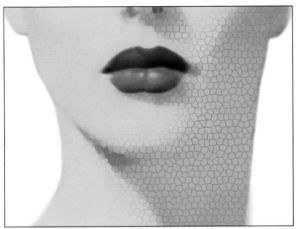

Fig. 2

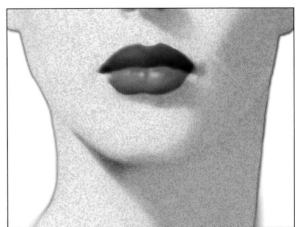

Fig. 3

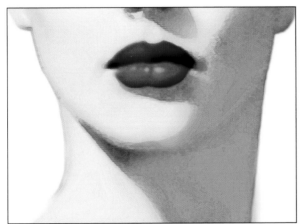

Fig. 4

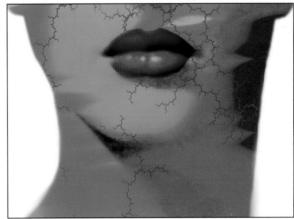

Fig. 5

Fig. 6

Fig. 7

Drop Shadows

Drop shadows are a popular and effective way to create dimension in art, and there are many ways to create them. When I need one in Photoshop, I make a mask of the object casting the shadow, feather the edge and offset the shadow in the opposite direction of the light source. The farther away you offset the shadow the higher the object will appear to float. Painter has a feature that creates drop shadows for you.

In the illustration opposite, the floating object is a popular Native American talisman called a dreamcatcher. The elements of the dreamcatcher were photographed separately and composed on the screen.

This assignment required that a second piece of art be created for the stepback. A common element in packaging

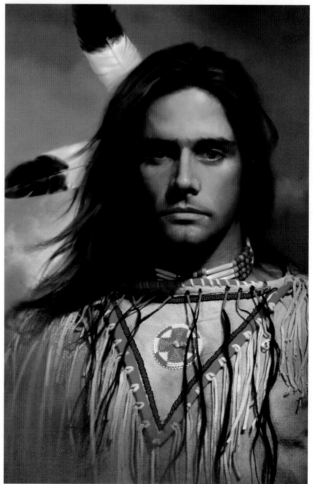

Fig. 1. This portrait of the main character was used as stepback art and became the basis for the front cover as well.

Fig. 1

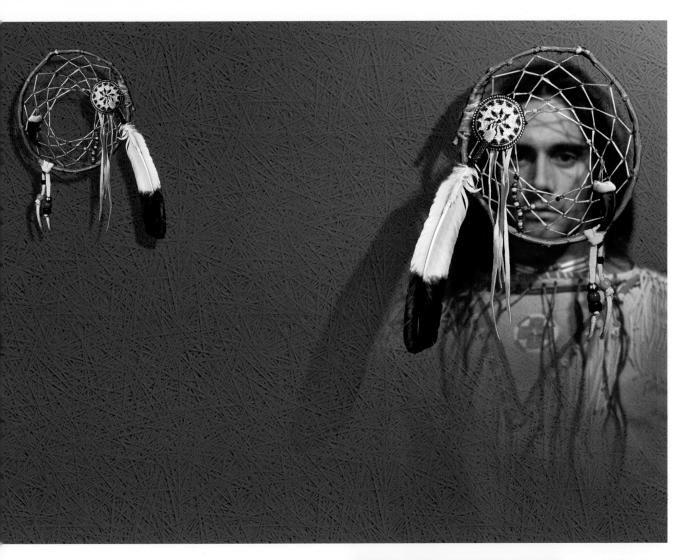

paperback books, the step-back is tipped into the book just under the front cover.

Having created a portrait of the main character for the stepback art (fig. 1), I made this image part of the front cover as well, by creating a copy, softening it, changing the color, and dropping it under the dreamcatcher into a textured background created in Painter .

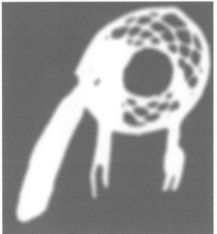

Fig. 2

Using the outline shape of the dreamcatcher, a mask was created (fig. 2) that was first feathered and then stretched using a Photoshop distortion feature. This mask was used to darken the pixels beneath the dreamcatcher, creating the shadow effect.

Type in the illustration

In this brave new world of computer graphics, the commercial art disciplines no longer have the natural boundaries they once had. Photography, illustration, graphic design, typography and even pre-press production can all come together under one digital roof: the computer.

In book publishing, illustrators and type designers are freelancers and rarely get the opportunity to collaborate. Type usually floats over the artwork as a completely separate element. It is easy now to allow the typography to become part of the illustration. This, of course, may not always be appropriate. But on occasion, as in this case, it could make for an interesting solution.

Fig. 1.
The cover art as it appeared before the type was added.

The preliminary version of "Deadwood" in figure 1 was created before the type was designed. When the type for the title arrived, it was engraved into the wood by beveling the edges of the wood surrounding the type. The type was filled with a color and burn marks were added to the adjacent area. Smoke was then painted in to add to the branded effect (fig 2).

A cast shadow was dropped behind the author's name to give it some dimensionality and add consistency to the cover. To create the shadow, the type for the author's name was copied into a mask and then distorted using Photoshop's perspective feature, and softened using a blur filter (fig. 3). This mask was then "floated" over the ground in such a way that it protected, or masked, the art everywhere but where the shadow would fall. Calling on one of Photoshop's many color adjusting features, this area on the ground was darkened, creating the shadow.

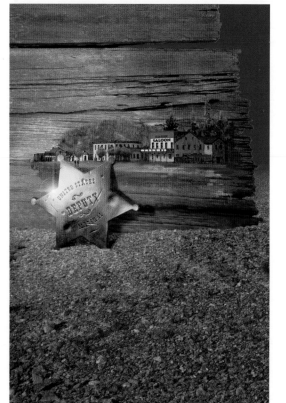

Fig. 1

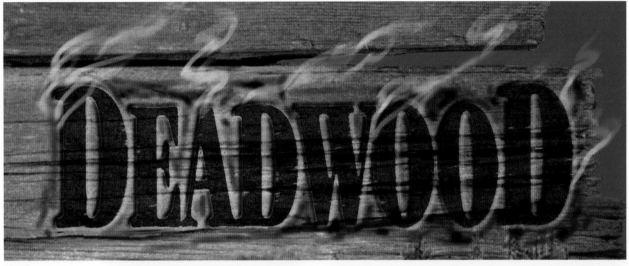

Fig. 2

Fig. 2. A close-up of the finished title.

Fig. 3. The mask used to create a shadow of the author's name.

Fig. 3

Fig. 4. The final book cover.

Evolving design

This illustration was designed for and used as a logo-border for the covers of a series of fairytale romance novels. During the course of the series, the design evolved continually as these images illustrate.

The original design shown left, included a twisted, intertwined vine that eventually gave way to more complex and colorful floral borders (figs. 2 through 4). Some of this illustration was drawn freehand (you're already familiar with that term, right?), while some of the flowers were imported as photos, and painted over.

Ultimately this border design would have to be printed over another piece of (yet-to-be-created) art as in figure 5. With this thought in mind, the flowers were separated into groups and placed on separate layers. In this way their color could be changed to complement each new underlying painting that would come later.

As the series developed, flowers and additional elements were added to accommodate each new book. The continuing evolution of this piece of art, and the capability to adapt it to new backdrops, offers a glimpse of the flexibility and editing power that the digital medium brings to the drawing table.

Eventually this little pixie was given her own day in the sun. Instead of being relegated to a border design she became the main element in the book cover shown below.

Fig. 1. Having been relegated to a supporting role throughout most of the series, the little pixie got top billing on the cover for "Midsummer Night's Magic."

Fig. 1

Fig. 2

Fig. 4

Fig. 3

Figures 2, 3, & 4 show how this design continued to evolve and adapt to underlying cover art.

Fig. 5. An example of how the design was eventually used.

Fig. 5

Scanning real life textures

The front cover art for Christina Dodd's novel "Once a Knight" was designed as a backdrop for type. Nevertheless, it had to offer a warm and appealing invite to potential readers, lead them to the stepback art and hopefully convince them to buy the book.

A piece of handmade parchment was scanned in on a flatbed scanner, and used as the backdrop. A virtual light was applied to the paper to illuminate the area behind the rose. Among the special effect filters included with Photoshop is a lighting effects filter. It allows you to cast a light on your work such as a directional light, an omni-directional light or, as with the rose, a spotlight. A color can be assigned to the light, and additional lights can be added as necessary. The rose was then brought in and a shadow of it was created using a mask.

Using customized Photoshop brushes, the flames were painted on a separate layer. I cannot emphasize how helpful it is using this layer option. The flames were painted, corrected, and repainted several times until I was completely satisfied, and all this before ever having to commit this layer to the final art.

On the physical book cover (fig. 1), a die-cut was made along the flame and burnt paper edge, revealing the textured side panel of the stepback art shown opposite (fig. 2).

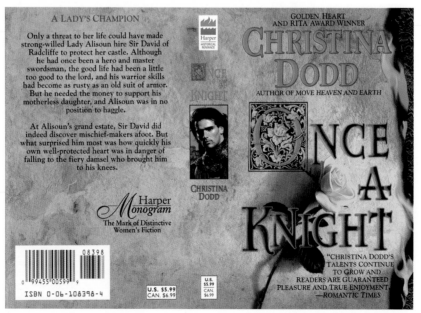

Fig. 1. The book cover.

Fig. 2. The stepback art.

Etching a digital texture

Publishers want an author's bookcovers to have a consistent style of design and imagery from one book to the next, and with good reason. This helps readers immediately identify their favorite authors on the bookstand. So creating a successful cover for a particular author often leads to working on subsequent titles as well.

Such was the case with Christina Dodd's next book, "A Knight to Remember." This book required a new cover idea while at the same time being consistent with the art for "Once a Knight."

In this case, the texture was made digitally. A custom color was created and used to fill the 8"x10" image file. The rust color panel was given texture by adding noise with the help of Kai's Power Tools (fig. 1).

Using the pencil tool, I drew the heraldry design in black and white. This was "etched" into the art using a series of masks and the use of Photoshop's emboss filter (fig. 2). Finding a black and white floral motif in a copyright-free collection of medieval designs, I used a similar technique to etch the inside borders. The outside purple border was picked up from "Once a Knight" and used both on the stepback edge and the back cover.

The smoke and poison ivy vines were combined and used to create their own drop shadows, shown in fig.3. The burning vines were actually part of the story and helped to create a similarity between this cover and its predecessor.

While these elements were still in layers, this working file weighed in at a whopping 97 megabytes before it was flattened to a mere 25 megabytes for delivery to the client.

Fig. 1. Shown here somewhat enlarged, these boxes show the effect of adding noise to a flat color.

Fig. 1

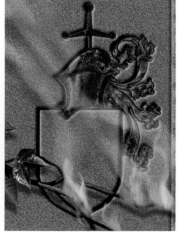

Fig. 2

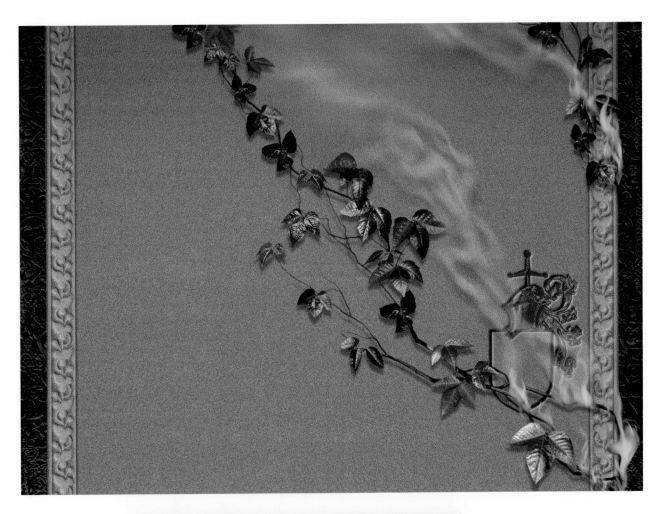

Fig. 3. The base layer with a drop shadow applied.

Working in 3-D

"Enchanted Fire" recreates the mythological story of Orpheus, a musician and poet, and his wife Eurydice whom he pursues into Hades.

Orpheus was famous for his skill with the lyre. Unfortunately, this instrument never survived antiquity, so finding a prop to reference was not an option. Instead, I decided to "build" a lyre—that is, a virtual lyre—in Adobe Dimensions.

Adobe Dimensions could be described as an entry level 3-D program. In it, I was able to create a three-dimensional instrument in wireframe mode (fig. 1), and render it using a texture resident in the program. In this "virtual" environment,

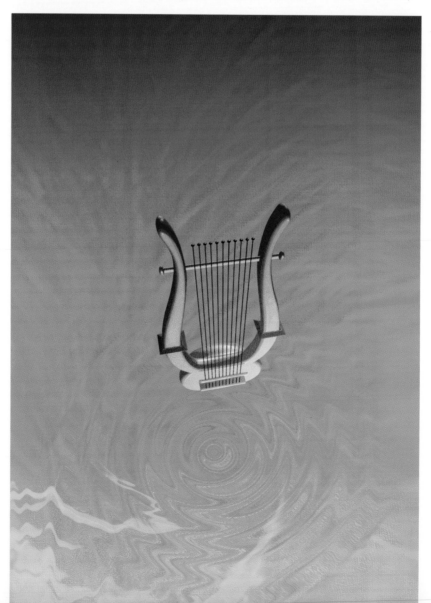

I was able to rotate and tilt the object, assign a color and texture to it, and then light it the way I might if it were in my real-life studio.

Most digital artists seem to have one program that they consider to be "home base," and Photoshop is mine. I copied the rendered version of the 3-D image (fig. 2) into Photoshop and began to create the final illustration. I should mention here, the beauty of a 3-D program is that you can return to it any time if you find later that you need to view the object from a different direction, assign a new texture to it, or change the lighting.

In Photoshop I created a red-orange gradient for the background. Using XAOS Tools' Paint Alchemy, a third party Photoshop plug-in filter, I gave the gradient a paintbrushed look. After masking out the top portion of the art to protect it, I applied Photoshop's zig-zig filter (fig. 3) to the lower half, creating the look of a fiery pool of water. For a finishing "fiery" touch, a few licks of flame were painted in at the bottom.

**Fig. 1.
A wireframe rendering of the lyre. This is the typical working mode for 3-D applications.**

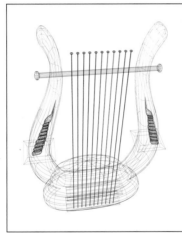

Fig. 1

**Fig. 2.
After choosing the camera view, lighting and texture, the object is rendered for use in Photoshop.**

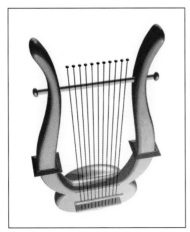

Fig. 2

Fig. 3

Fig. 3. Paint Alchemy was used to create the brushy look in a simple red-orange gradient. Photoshop's Zig-Zag filter was then applied to the bottom half to make the pool of fiery water.

Color correcting

This illustration was part of an ongoing series of romance novels involving Native Americans. In keeping with the look of the rest of the series, a background texture was needed to support the still life elements. Beginning with a photo of tree bark (fig. 1), the bark was cloned to cover the entire area of the front and back cover, and colorized with a green cast to create the feeling of deep forest.

Photoshop offers lots of ways to adjust the color of an image. You may come to use all of them at some point, but the easiest way to get started with color correction in Photoshop is with Variations (fig. 2).

This tool allows you to adjust color incrementally or in large jumps, and its layout will help you to understand how the colors of the additive color wheel interact with each other.

After cloning the grey bark to fill the entire image, it was changed to a green hue. The Splatter filter was applied creating the mossy look, and a drop shadow was added (fig. 3) to anchor the still life elements.

Fig. 1. Photo of tree bark taken by the author.

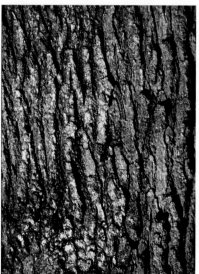

Fig. 1

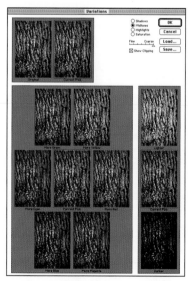

Fig. 2

Fig. 2. Photoshop's Variations dialogue box for color correcting.

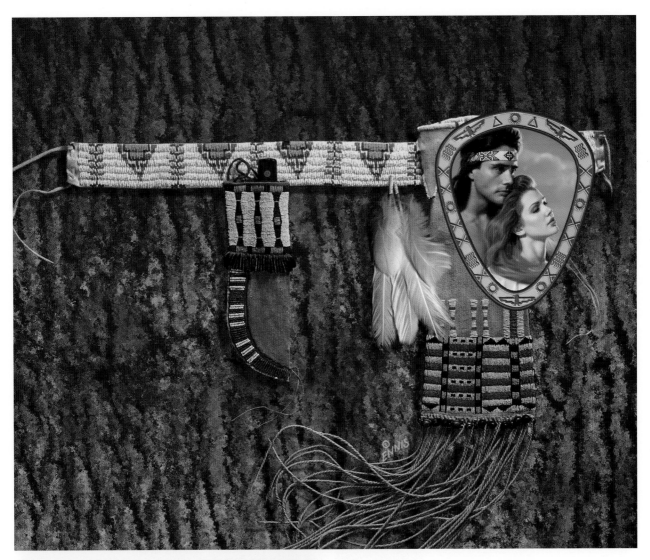

Fig. 3. This mossy
green look,
created with the
Splatter filter,
was given a drop
shadow to anchor
the still life.

Fig. 3

Working with Scanned Art

This book cover assignment involved two pieces of art. The first was a front and back cover illustration which is referred to in the industry as a wraparound. The second piece of art, called the stepback, would be tipped into the book just inside the front cover. A portion of the stepback would show through the outside cover.

Beginning in the photo studio with models, costumes and props, the model in figure 1 was photographed with slide film and then scanned into the computer. The background was eliminated, and the figure was scaled to fit on the horse (fig. 2).

Several years ago I created an oil painting of galloping horses (fig. 3). I had always wanted to use this art for a book cover, and the opportunity came with this assignment. Measuring 26"x38", it was too large to place on a flatbed scanner. Instead, a 35mm transparency of the art was made and scanned into the computer.

Regardless of their original media, all the elements are now in the same medium, pixels. The horse and rider, and an additional figure, were dropped into the painting, and I began to paint (digitally) over the entire image. This became the back cover art for "Savage Shadows."

Fig. 1. Studio photograph taken by the author.

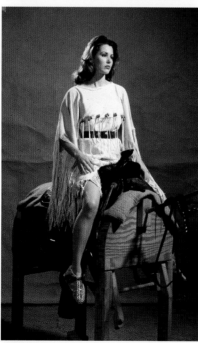

Fig. 2. With backgrounds eliminated, these two photos were scaled to fit each other.

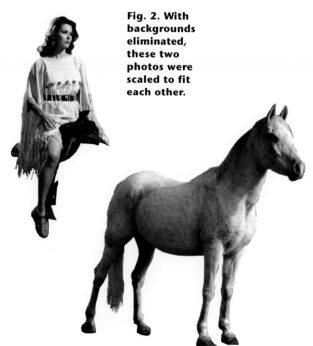

Fig. 1

Fig. 2

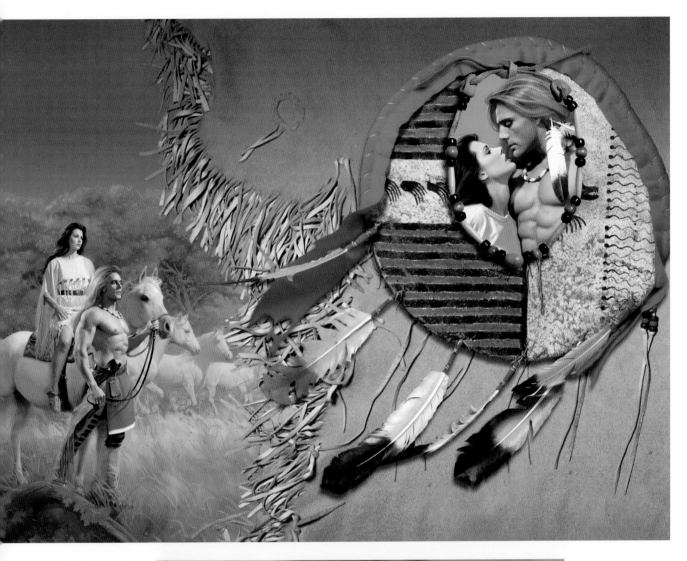

Fig. 3. "White Horses," an original oil painting created by the author, became the backdrop for the cover art.

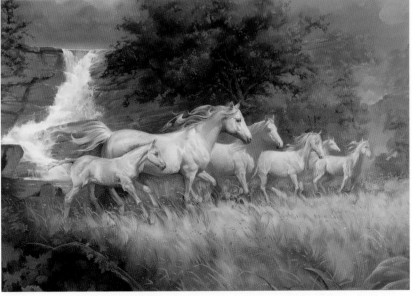

Fig. 3

The Native American artifacts shown on this page, (figs. 4, 5 and 6) were photographed in my studio and combined together in Photoshop. Cast shadows were made to create the illusion that they were sitting on top of each other as they were grouped into a composition. These images were cropped, flopped, and otherwise manipulated in Photoshop to get the look I wanted, but were to remain essentially "photographic."

The stepback art (fig. 7), originally created as a separate file, was placed as a layer underneath this still life, and the area inside the necklace (fig. 6) was deleted to allow a portion of this art to show through (fig. 8).

Figures 4, 5 & 6. Native American artifacts, photographed individually, were combined in Photoshop to became part of the cover art.

Fig. 4

Fig. 5

Fig. 6

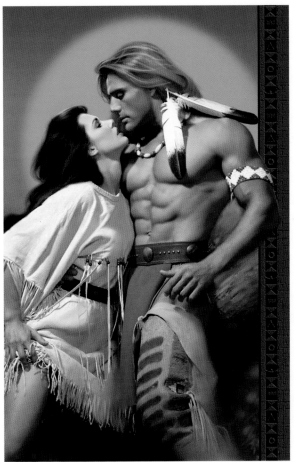

Fig. 7. The stepback art.

Fig. 8. The inside area of the necklace is cut away to reveal the stepback art.

Fig. 9. The printed cover.

Combining Applications

"The Bridge" and "The Player of Games" (see following pages) are science-fiction classics by British author Iain Banks. Commissioned by HarperCollins to illustrate the cover art for a reissue of both books, I conceived and designed these covers as companion pieces. This was challenging since, aside from a common author, these stories share little else.

The story of "The Bridge" describes a surreal dream the main character experiences while in a coma.

The suspension bridge you see in the illustration was literally "built" (or if you prefer, "virtually" built) in the 3-D program Ray Dream Designer (fig. 1). Creating an object in a 3-D program is much like building it in real life in the sense that you have to put it together piece-by-piece, bolt-by-bolt. This can be immensely time consuming, but once you have it you can view it from any angle, and apply different textures and lights to it. In a virtual sense it is like having the object in your studio.

Satisfied with the construction of the bridge, it was then rendered in the Ray Dream program and exported to Photoshop. Here the twirl filter was applied (fig. 2) to distort the bridge, giving it a dream-like quality. The train image (a photo) was added and distorted vertically to further this mood.

Turning next to Adobe Illustrator, an object- and type-

Fig. 1. Created and rendered in Ray Dream Designer, the bridge was brought into the Photoshop file looking like this before it was distorted.

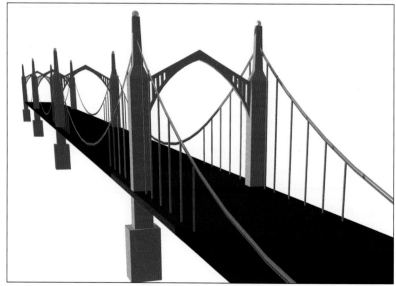

Fig. 1

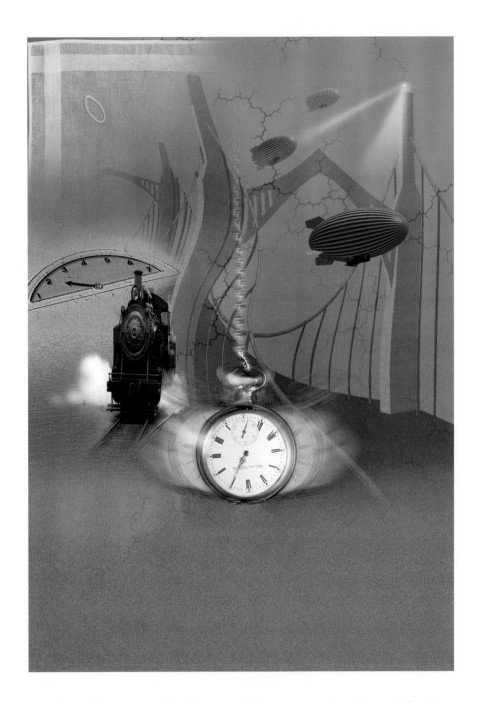

oriented program, the elevator dial was created as line art (fig. 4) and imported into Photoshop where it was used to help create the concrete-like image you see in figures 5 & 6.

Next, floating blimps were created in Bryce. This application, known chiefly as a 3-D landscape program, is easier to learn and use than many object-creating 3-D programs. Using

Fig. 2. The twirl filter being applied.

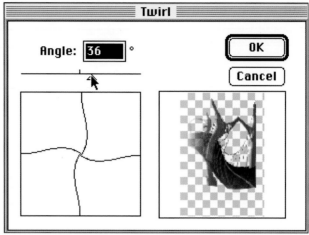

Fig. 2

Fig. 3. The result, a swoozy suspension bridge.

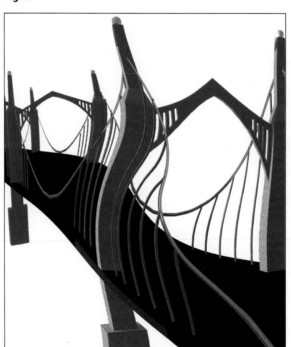

Fig. 3

Fig. 4. Line art created in Adobe Illustrator was used as a starting point in making the elevator dial.

Fig. 5. Once in Photoshop, the noise and emboss filters were used to help give texture and dimension, and the numbers were given drop shadows.

Fig. 6. Gallery Effects Craquelure filter was applied to add cracks to the concrete. A distortion tool was used to add perspective.

primitive geometrics (spheres, cubes, etc.), I was able to piece together a simple blimp structure, and apply a texture to it (fig. 7). The rendered image was brought into Photoshop, and finally, as with most of the other elements, was made semi-transparent and layered over a background (fig. 8) created with KPT Texture Explorer, a third-party Photoshop plug-in.

The final piece of the puzzle, my grandfather's pocket watch (circa 1904), was photographed and scanned in to become the focal point of the cover art. It was given motion through the use of a blur filter resident in the Photoshop program.

Fig. 7. The Bryce Interface.

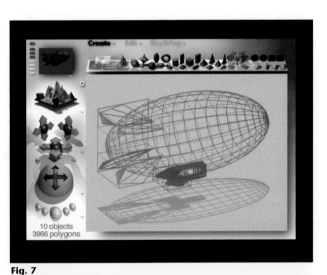

Fig. 7

Fig. 8. An abstract background created in Photoshop with Kai's Power Tools Texture Explorer.

Fig. 8

Bryce and Ray Dream

In making the art for this book cover, I was constantly comparing it to "The Bridge" in order to maintain a consistent style and composition. In addition, I wanted the two book covers to look good together, side-by-side on the shelf. To that end I gave them complementary color schemes.

To create the outline shape of the playing cards, I once again turned to Adobe Illustrator. Importing this shape into Photoshop, I opened a third party plug-in filter from XAOS Tools, Inc. called Paint Alchemy. This filter applies brushstrokes to an existing image, and in this case to a blue gradient I created with the gradient tool (fig. 1).

A similar approach was used with the fire card (fig. 3), the licks of flame being brushed on after the fact. Using Bryce, a desert landscape was created to represent the earth card (fig. 4). These three images were set up as separate layers and arranged, along with cast shadows, to form the card composition you see in the art.

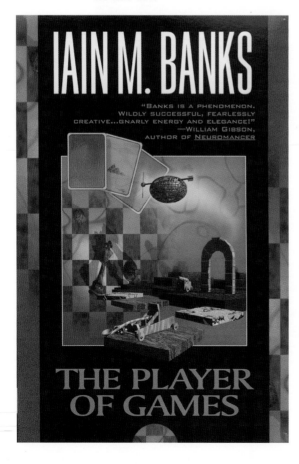

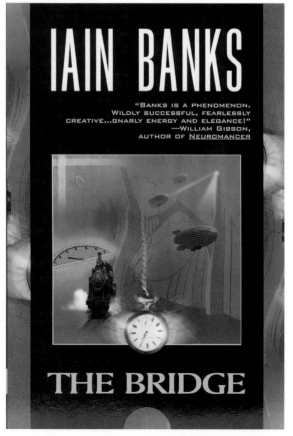

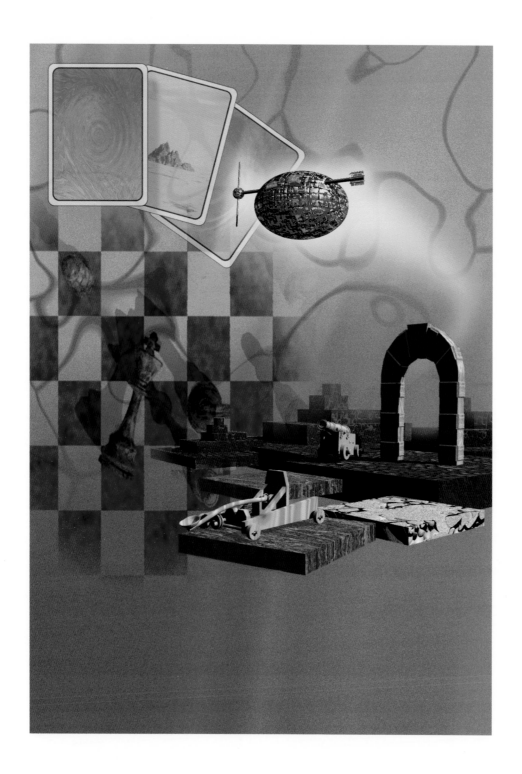

Using a combination of Bryce's primitive objects, I was able to create the flying robot in the illustration. Shown in wireframe mode in fig. 4, I applied a material to the surface and rendered it in Bryce (fig. 5). This material, displayed on a flat object in fig. 6, is one of many textures that come with the program. Of course, you can modify these textures or create your own if you like.

This robot could have been done in a more object-oriented 3-D program, like Ray Dream or Infini-D, but Bryce is so much fun that I prefer to use it whenever I can.

Fig. 1. The Paint Alchemy filter applied to a blue gradient.

Fig. 1

Fig. 2. The water card, created by applying Photoshop's zig-zag filter to the art in fig. 1.

Fig. 2

Fig. 3

Fig. 4

Fig 3. After using a similar technique used to make the fire card, a few licks of flame were brushed on.

Fig 4. This image was created in Bryce.

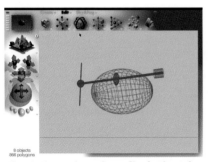

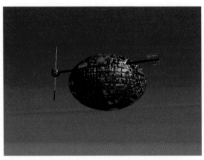

Fig. 4. Bryce interface displaying the wireframe construction.

Fig. 5. The Bryce-rendered robot.

Fig. 6. The same material applied to a flat object.

Fig. 7. The chessboard as rendered in Ray Dream Designer.

A chessboard (fig. 7) created in Ray Dream Designer was imported into the Photoshop file and distorted in a way similar to the train image in the bridge illustration. This again was done for the sake of style consistency.

Feathering and color adjustment tools were used throughout to bring the final composition together.

Using a Flatbed Scanner

"Frankly My Dear" is a book that pays homage to the classic story "Gone with the Wind." I was asked to create cover art that payed similar homage to the poster art for the movie. While this art was under way, I received an early morning phone call from the art director suggesting that we give the book cover a "classic" appeal by adding burgundy leather panels.

A flatbed scanner is not an essential item in the digital artist's studio, but there are times, as in this case, when it really comes in handy. After purchasing an imitation leather suitcase for $5 at a nearby Salvation Army store (fig. 1), a panel was cut out, laid on the flatbed scanner and "captured" in Photoshop, where I used the color correction tools to change the color to burgundy. This all took place before lunch.

The figurative part of this illustration, created entirely in digital media, is indistinguishable from my oil painting technique, which has always been very realistic, incorporating soft edges and smooth skin tones. Photoshop's brushes lend themselves to this kind of painting if you lower the opacity setting. Using these brushes to paint the couple in a fiery setting, I went on to copy, resize and feather the image so it could appear on the frontcover, backcover and spine of the book.

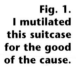

Fig. 1. I mutilated this suitcase for the good of the cause.

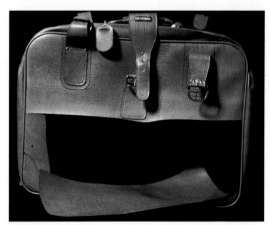

Fig. 1

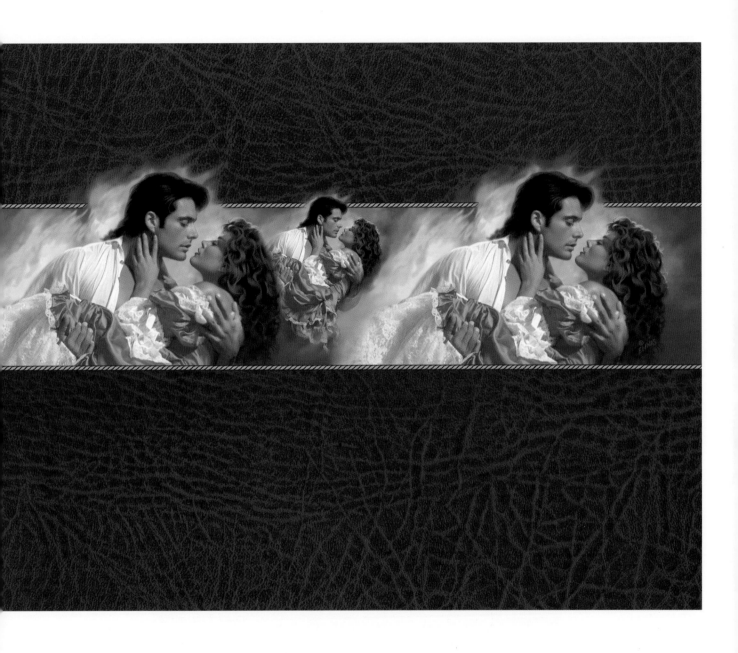

Masking Layers

A recently released (but of course innocent) ex-convict living in New Orleans is the setting for "Jackson Rule." I used the layers option in Photoshop to help create and later edit this illustration.

The bottom layer (fig. 1) was created first by using the gradient tool. The gradient tool creates a gradual transition between two colors and looks like an airbrushed background. I haven't used an airbrush in years, but I remember how tedious and time-consuming this would have been. Creating this part of the art took less than a minute. The "noise" filter was then applied to add more texture to the background.

Next I painted the hero on a separate layer (fig. 2), and floated it over the background in fig. 1. Each layer in Photoshop can be given a mask and I created one for this layer by using the gradient tool (fig. 3). This made the bottom

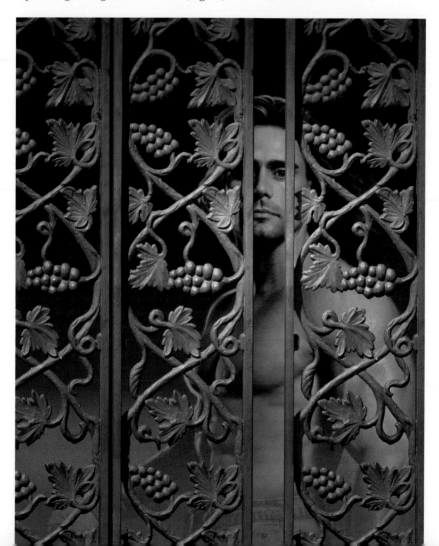

Fig. 1

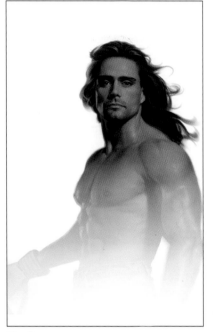

Fig. 2

Fig. 3

portion of the hero semi-transparent, allowing it to visually mix with the background (fig. 4). The effects that these individual layer masks create do not permanently affect the art until you tell them to. This means that you can continue to edit their effect throughout the course of the painting.

The wrought iron image in fig. 5 became the topmost layer in this digital sandwich. The file size at this stage is about 35 megabytes and I saved it here with the layers still floating.

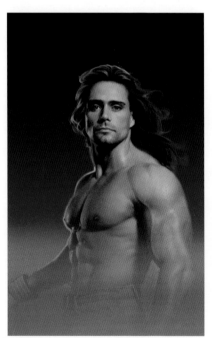

Fig. 4

Fig. 5

Once saved, the file was "flattened" by compressing the layers into one, and renamed to keep the two files separate. The flattened image was now a more manageable 13 megabytes. This was copied onto portable media (see Section Four for more on this) and delivered to the client.

While happy with the results, the art director asked if I couldn't open up the gate an eighth of an inch to reveal more of the man's face. Can you imagine making a change like that in oil paint? Having saved the gate as a separate layer, this change to the art was painless.

Fig. 1. This background gradient became the bottom-most layer.

Fig. 2. The effect of the gradient mask, partial transparency.

Fig. 3. A mask created with the gradient tool.

Fig. 4. This is how these independent layers appear on the screen.

Fig. 5. The topmost layer, a wrought iron gate.

Using textures in Painter

Done entirely in Painter, this illustration represents only a fraction of what this program is capable of.

Texture is a big part of Painter. If you like painting on toothy canvas or drawing on textured paper because of the visual effect it creates, then you will love this unique feature that Painter offers.

After creating a piece of artwork, you could apply a texture to the entire image (fig.1). Or you could assign a particular texture to a brush, and that brush will allow you to create brushstrokes that reflect the texture (fig. 2). The program comes with resident textures like canvas or paper grain. What's more, you can import your own textures to create an unlimited variety of background surfaces.

In the illustration opposite, I used several of Painter's brushes and textures. In addition, I imported one of my own textures, a photograph I took of worn concrete. After scanning it into Photoshop, it was converted to greyscale (fig. 3) and "captured" as a Painter texture. Fig. 4 shows a single brushstroke using the chalk brush with this concrete texture assigned.

Fig. 1. Painter's canvas texture as applied to a flat color.

Fig. 1

Fig. 2. The same texture assigned to the chalk brush.

Fig. 2

Fig. 3. A greyscale photo of worn concrete taken by the author.

Fig. 3

Fig. 4. This imported texture assigned to the chalk brush.

Fig. 4

Weaving in Painter

Painter contains a somewhat obscure feature called weaves. The Weaves Palette has a library of textile patterns, among them the Scottish tartan used in the illustration opposite. You can, of course, design your own textile pattern if you prefer.

In this case, I began by filling an image file with a tartan pattern. The pattern is flat at this stage (fig. 1). Painter automatically creates a mask for each layer, and using a surface control feature based on the mask, I was able to create the illusion of dimension (fig. 2). It is not important that you grasp exactly how this is done right now. Just be aware that it can be done.

After painting in the pin, I used a distorting brush to stroke the pattern, giving the impression that the pin is passing underneath the fabric (fig. 3). The circular design and heather were added as separate layers, called floaters in Painter, and given a drop shadow.

Lastly, using one of the many brush/texture combinations, the red "smoke" was added.

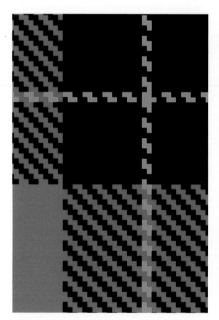

Fig. 1. A magnification of the flat pattern.

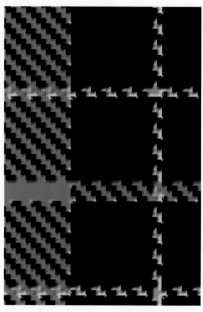

Fig. 2. Dimension is added using surface control.

Fig. 3. A distortion brush was used to stroke the pattern as the pin passed through the material.

Imitating Art

"Tallchief" is a story about a Native American painter and I wanted to convey this message visually.

Beginning with Painter's colored pencils, I began this art the same way I used to begin an oil painting. Pencil outlines were followed by color washes, in a build up method that seemed very familiar. During this underpainting stage, each brush was assigned the canvas texture to give tooth to the brushstrokes (fig. 1). When oil paint builds up on a canvas, the tooth becomes less evident. To replicate this look, the texture option was dropped as the painting progressed.

The Gallery Effects filter Texturizer was applied to the entire image at this stage, which offers canvas as one of its choices. You can see the effect of this in the enlarged detail (fig. 2) shown opposite.

To complete the illustration, a photographic still life was composed in Photoshop, paint was added to the brushtips. The group was given a drop shadow and placed over the art.

**Fig. 1.
A build up
method similar
to real-life oil
painting.**

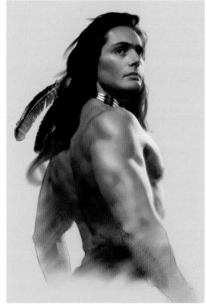

Fig. 1

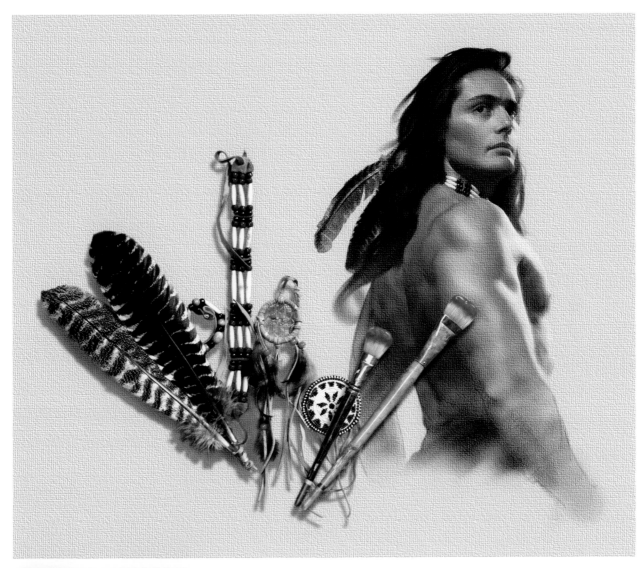

Fig. 2. An enlarged detail of the face, showing the canvas texture created by the Texturizer filter.

Fig. 2

Booleans and Bryce

The art shown opposite was created for the jacket sleeve of a book by science fiction authors Anne McCaffrey and Margaret Ball. Acorna, the main character, hails from a race of beings sharing human and unicorn characteristics.

The foreground elements were painted in Photoshop. The background, including the water and airspeeders, was a single scene created in Bryce. The two scenes were brought together in Photoshop.

Although Bryce is a 3-D application designed for creating landscapes, it offers what are called primitive shapes. That is, spheres, squares, pyramids, cones etc. as starting points for creating more complex objects that can be included in the scene. These primitives can be stretched or shortened in any dimension to alter their shape, and combined with others to form more complex objects. In addition, these shapes can be assigned a negative attribute, which allows you to cut away part of an object (fig. 1).

In the case of the airspeeder created for this illustration, combinations of positive and negative shapes, called booleans, were used to create the 3-D design shown on the following pages. Once this object had been created, I was able to use it several times in the cover art.

Fig. 1. This object began as a sphere. It was placed inside a square, allowing some of the surface to extrude. When the square was assigned a negative attribute, this boolean object was the result.

Fig. 1

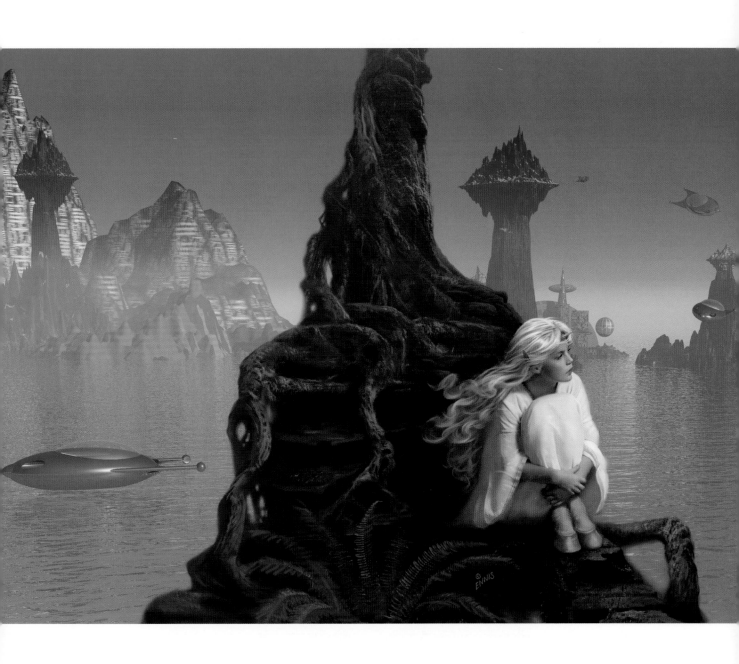

Fig. 2. Top view of the speeder in wireframe mode. The oval at the top has been assigned a negative attribute. This cuts away an oval shape from the wings.

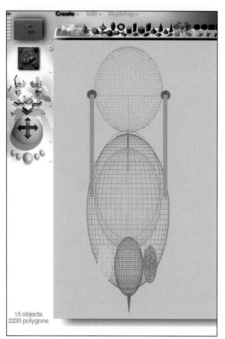

Fig. 2

Fig. 3. To help visualize this, the wireframe is laid over a rendering.

Fig. 3

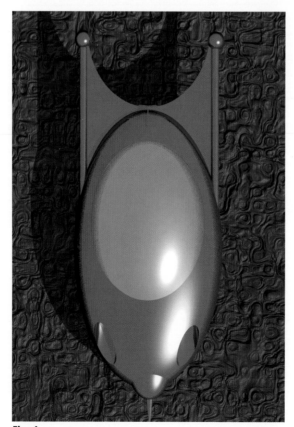

Fig. 4. A finished rendering from top view.

Fig. 4

Fig. 5

15 objects
2220 polygons

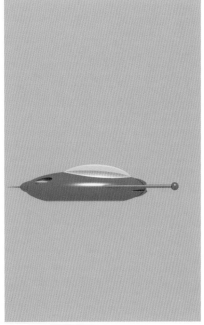

Fig. 6

Figs. 5 & 6. As seen from the side, negative attributes were also assigned to a rectangle at the bottom, and ovals for the front air intakes. A chrome texture was given to the craft's body, and glass to the cockpit cover.

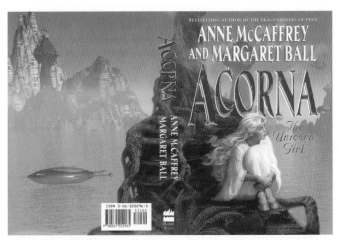

Fig. 7. The final jacket sleeve.

Embossing type

Embossing and engraving are opposite sides of the same coin. Engraving into a material or embossing out of it are optical illusions. In the illustration opposite, edge planes were added to the type. The top and left edge planes were given a higher value and the bottom and right planes a lower value to create the illusion that light is coming from the top, a position you might subconsciously expect the light source to be located.

Below, in figure 1, the opposite is occurring. The bottom and right edges are lit. In addition, the inside shapes are darkened. This helps to create the illusion that the words are engraved instead of embossed. If you look at these images long enough, what you thought was engraved might start looking embossed. It is all a presupposition in your mind.

Earlier in this section, I described a masking technique that you could use to engrave or emboss. In this case, however, I took a shortcut and used a third-party Photoshop filter called WildRiverSSK.

Fig. 1. An unused version engraved in marble.

Fig. 1

Fig 2. The actual book cover.

Fractal Design's Poser

Stephen King created a story in six parts, each published as a separate mini-book. I was called on to create cover art for a publication of the story as a single book.

The central figure, John Coffey, is a giant of a man. Finding a model of his build would have been difficult, so I turned to Fractal Design's Poser program. While no substitute for live models, this program is great for preliminary work, and as in this case, for finished work, provided realistic detail is not a requirement.

Poser is a 3-D application. Beginning in wireframe mode (fig. 2), a standard figure was created, and individual body parts were expanded to create the stocky man the story required. The figure was lit from behind and more softly on top, to simulate the lighting in the final art. The rendered version (fig. 3) was placed in a Photoshop image.

This is a death row story, and the cell block was created in Bryce, rendered and imported into the Photoshop file. Here, masks were used to create the lighting effects and reflection of the figure on the floor. Mr. Jingles, the resident mouse and silent spectator of this captivating story, was created on a separate layer.

Fig. 1. The book cover.

Fig. 2. Fractal Design's Poser interface shows the figure here in wireframe mode.

Fig. 2

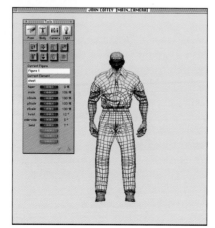

Fig. 3

Fig. 3. The rendered figure, ready for export to Photoshop.

82

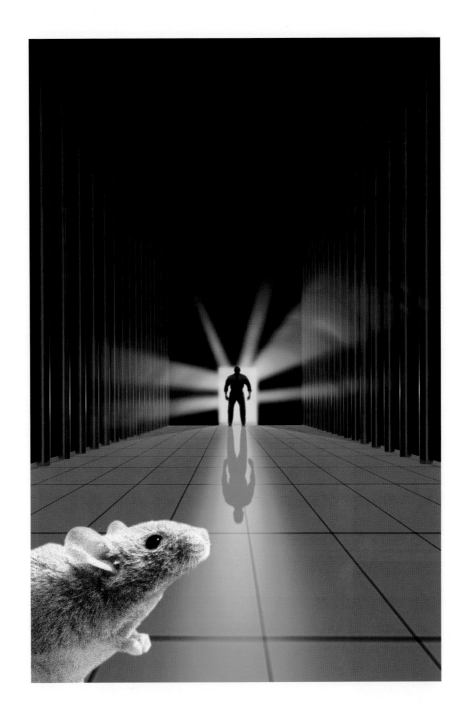

Painter's Image Hose

Fractal Design's Painter program offers a feature called the Image Hose. Instead of painting with just color, it lets you paint with images. The author's name (opposite) was created in beadwork using this tool.

Beginning with an elliptical mask as the outside shape, a single bead was created using Painter's airbrush tool (fig. 1). This image was saved and loaded as a "nozzle" onto the image hose. I practiced with the size and spacing (fig. 2) until I was satisfied and began illustrating the letterforms (fig.3). The image hose is being employed here at its most basic level. It is capable of a great deal more complexity. Several images can be included into one nozzle, random sizing and spacing can be added, and so on.

I do lots of bookcovers with Native American motifs, so I am always looking for new ideas. One day, my son Kyle came home from kindergarten and drew an image in the steam on the shower door. "Daddy, this is the Indian sign for good journey" he said. The next day in the studio, I was embossing similar icons into deerskin for the cover art of "Savage Tears."

Fig. 1. A single bead created in Painter using an oval mask and the airbrush tool.

Fig. 1

Fig. 2. Making brushstrokes with the Image Hose is lots of fun.This practice run had much tighter spacing than the setting used on the book cover.

Fig. 2 Fig. 3

Fig. 3. An enlargment of the work in progress. Creating the beaded letterforms was time consuming, but doing this in a real life medium would be unthinkable.

84

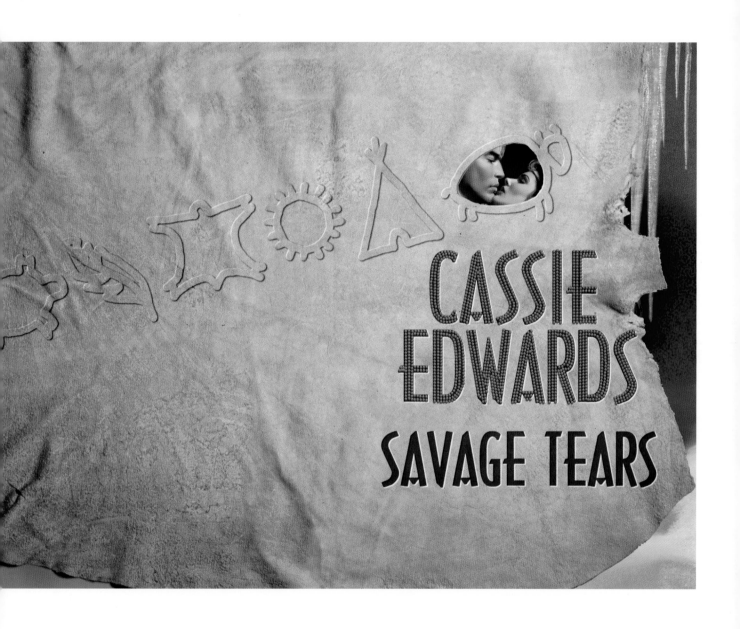

Bringing it all together

The idea for the cover illustration of this book you are reading began the old fashioned way—on a restaurant napkin. And, amazingly enough, the finished piece actually resembles the original sketch (fig. 1).

Using the pen tool in Ray Dream Designer, a two dimensional outline of the artist palette was drawn. The thumb hole was added and combined with the outline to form what is called a compound shape. That tells the computer to punch a hole inside the palette. This flat drawing was then extruded to give dimension. Ray Dream Designer has its own format for saving files, but it also allows files to be saved in a more or less universal 3-D format called DXF. In this way, I was able to transfer the wireframe art to Bryce.

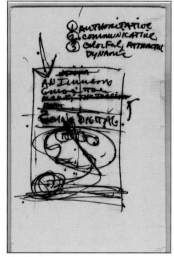

Fig. 1

The mouse was also created in Ray Dream Designer. It was composed of three sections: top, middle and bottom (fig. 2). If an object is simple enough, it is sometimes better to export the parts separately to Bryce and reconstruct them there. Bryce seems to move along faster when I do it this way. Complex DXF files can slow Bryce down considerably.

Fig. 2. A screen snapshot of the Ray Dream Designer interface showing the mouse under construction in one of the preview modes.

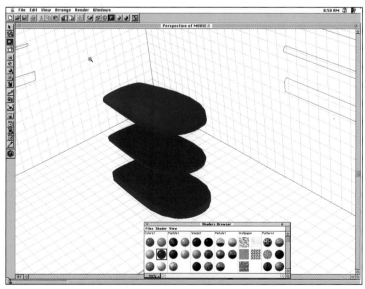

Fig. 2

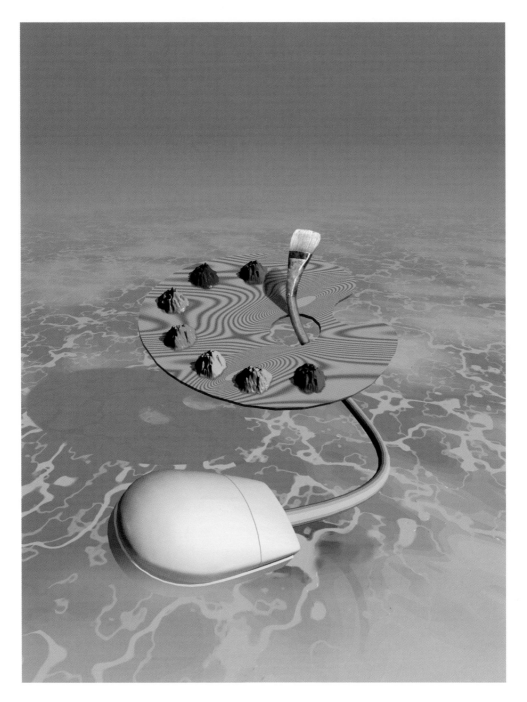

Once inside Bryce, the palette was assigned a wood texture. Small mountains were created, assigned paint colors and spread out over the palette. Next, the mouse was given a putty color and a texture quality of muted shininess similiar to plastic. An ocean was created below the objects, fog and haze were added, and the sun was moved around until a position was found that cast everything in a pleasing light and cast a shadow of the palette onto the water. The scene was then rendered, a process

that took over three hours. The resulting image was saved and imported into a Photoshop document.

If I am making this sound easy, it wasn't. Bringing the art to this stage took four solid days of intense work.

The next step involved a photograph I had taken of one of my real paintbrushes, one that had seen some action. Opening the photo in Painter, the warp feature was used to bend the brush into a curved position (fig. 3). This was then added to the working Photoshop image where it was cut, pasted and finessed into looking like an extension of the mouse cable.

Ray Dream Designer, Bryce, Painter and Photoshop were all used to make this illustration. Please consider that you will need to brave the learning curve of these four complex programs in order to take advantage of the options featured here. My advice is to take them one at a time.

Fig. 3. A photo of a used paintbrush was twisted with Painter's Warp feature.

Fig. 3

Interview

Section Three

A *great deal of understanding can be achieved through
conversation. To that end, the following interview is presented
with special thanks to renowned traditional illustrator and author
Wendell Minor.*

WM: Before we get started here, I have to say that I was visually
blown away by your show last year at the Society of Illustrators
"Transition to Digital." When I looked at your work I assumed
it had been done traditionally. Then I realized it was created on
the computer and said "Wait a minute, let me take a closer
look at this." I was really excited and I called you to talk to you
about it.

JE: I remember.

WM: You're the first illustrator I'm aware of who has taken a realistic
painting style to the digital medium, and done it so
successfully that I had to look at it carefully to see that it
wasn't painted on canvas.

JE: The question most often asked about that show was did I
create oil paintings and scan them into the computer. This was
very hard for people to understand.

Art copyright 1992 by Wendell Minor

Cover art for "Truman."

About Wendell Minor

Wendell Minor is a former
president of the Society of Illustrators
with more than 200 awards to his
credit, including silver medals from
the New York Art Directors Club, the
Society of Illustrators, and SILA.

He is represented in five American
museums, and has had several solo
exhibitions, most recently at the Art
Institute of Chicago.

Minor has designed and illustrated
well over 1500 book covers including
Pat Conroy's "Beach Music" and David
McCullough's Pulitzer Prize winning
biography "Truman." He has illustrated
ten children's books, and has created
several stamps for the United States
Postal Service as well as prints for the

Norman Rockwell Museum.
"Wendell Minor: Art For the Written
Word," a retrospective of twenty-five
years of Mr. Minor's book cover art
was published in 1995 by Harcourt
Brace & Company.

WM: Which brings us to the point of your book. You are trying to explain to non-computer people what these various aspects are and hopefully we can clarify them here. I know you take photographs as reference. Do you scan them into the computer?

JE: Yes I do. I work with both figurative and still life artwork. I photograph still lifes here in my studio. For my figurative work, I photograph at a studio in New York City where I hire models and rent costumes. In both cases, the next step is scanning the slides into the computer.

WM: Is there anything left of the photograph after you've painted over it?

JE: Hopefully not. I have always used photographic reference as a point of departure. I redraw and repaint it to create the esthetic that I am trying to express.

WM: So your tradition, your knowledge and your experience as what I call an analog artist has helped you to grow in this digital medium.

JE: That's true. Everything I've learned as an oil painter is being applied to this new medium. I've been able to recreate my oil look. But it would be misleading to say that was my goal and that was enough. I am able to do much, much more with these tools.

WM: I would like you to talk about the main difference between approaching an assignment in the traditional way and how it is done now. How has your thinking changed?

JE: I used to think in my painting style and was aware of my capabilities and the limitations of oil paint. This new medium lends itself to exploration so easily that the possibilities seem endless.

WM: You know that I work on the computer as a designer and I scan

in my conventionally done watercolors, but I've discovered that having infinite options is extremely frustrating at times. How do you know when to stop?

JE: When the job is due.

WM: Good point. But don't you feel that you could sit and do infinite numbers of solutions? Are you doing some mental editing and not just going on ad infinitum into the options that digital allows you to consider?

JE: It's easy to lose yourself making art this way. I generally set out to make a picture that I've conceived of either on paper or in my head. Once I arrive at that, I will often go back to an earlier stage of the process and branch out in different directions. I end up doing two or three very different solutions to the same problem, often based on the same reference material.

WM: Now, do you show those two or three options to the art director?

JE: Yes, more often than not.

WM: I assume that is a wonderful diffusing device; in other words, if they don't like this one, you've got that one. It's already there in front of them so they're more likely to accept what you've done.

JE: They usually find one that they like.

WM: Let's say I'm a traditional artist, which I am, and I want to make this transition and the biggest question in my mind is, how much money is it going to take?

JE: You will be spending ten to fifteen thousand dollars.

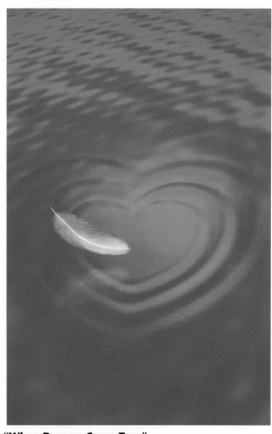

"When Dreams Come True"

WM: That usually is a heart-stopping amount of money for most illustrators, even established illustrators.

JE: That's true.

WM: Do you suggest that someone take courses where they have computers available so they lose their inhibitions by getting some hands-on experience before they buy?

JE: I suggest that they take a course at a local community college or art school. Introduction to the Macintosh or PC and an Introduction to Photoshop would be good first choices.

WM: Is that what you did?

JE: That's what I did, yes.

WM: How were you first introduced to the computer?

JE: My wife is a graphic designer and she was urging me to buy a Mac so that she could learn how to use it. Once I got my hands on it and realized what a great tool it was for making art, I never let her have it. I had to buy another one.

WM: That's great! So you were introduced to this new technology inadvertently through your wife.

JE: I guess so. It was not deliberate on my part at all.

WM: And had that not happened you might still be a conventional illustrator.

JE: Yes, that's possible.

WM: So it was in front of you by chance and therefore the experience was a little less intimidating.

JE: I think it is a great leap of faith to go out and buy a computer like this. It's a big dollar investment, not something you can

wade into slowly, and as a result it's a big challenge to commit not just the financial resources but also to the huge learning curve. It involves a tremendous time commitment. Most of us are working, making a living and have very little spare time.

WM: It's as if you have another career overlapping your existing career. How long did the learning process take for you?

JE: I struggled to learn this thing for months before I went "public" so to speak. It took a full year to make the transition from 100% oil painting to 100% digital painting.

WM: That's extremely fast.

JE: I've heard of people doing it in less time. During this period I had a full docket of work to complete on the board. I would take a couple days off at a time, or work at night and weekends learning the computer. Finally I got to the point where I felt self-confident enough to show samples. Then I talked an art director into allowing me to create a digital illustration instead of an oil painting.

WM: What was driving you to make such a commitment to digital illustration?

JE: I knew I could be more creative in the digital environment. There were more things that I could do digitally than I would ever be able to do in oil painting. And in fact the first digital illustration I did involved a motif carved in stone. This would have been a real trial in oil paint.

WM: I remember seeing it in the show. It was quite a beautiful piece. I looked at it and said "How did he do it?" Was that the first time you said "This is it for me?"

JE: No, I had said that to myself early on when I was experimenting. You have to experience painting digitally to really appreciate its capabilities.

WM: I sell a lot of my original paintings. As an artist who still paints conventionally, one of the big issues that concerns me is the fact that the digital art form does not produce an individual original painting. Does that concern you at all?

JE: Yes, in fact I would say if there was one drawback to this medium for me it's not having the original oil painting. But from a practical standpoint, the original is a byproduct of the illustration process. And I have got hundreds of them in my attic.

WM: Getting back to the technical stuff, are you working with a pressure-sensitive tablet?

"Dancing On Air"

JE: I don't think I could make art in the computer without it. The stylus that comes with the tablet allows for the kind of brushstroke I was used to making with a real-life brush. Drawing with a mouse would be like drawing with my elbow.

WM: How long did it take for you to feel comfortable drawing on screen in terms of your eye, hand, and mind coordination?

JE: It feels awkward at first, but I overcame it within a couple of days.

WM: I know you have an acetate cover on your tablet. Do you ever put sketches under your acetate cover and quickly sketch out something?

JE: I've done that once or twice but you can just as quickly sketch with the pencil tool right in Photoshop or Painter.

WM: What do you consider the most difficult aspect of going digital?

JE: Reading manuals. There's just too much to learn and you have no choice but to refer to the manual.

WM: But don't you find that the more you learn, the easier this gets?

JE: The learning process is cumulative. The day Photoshop arrives in the mail you open the package and out falls this one-inch thick book. Its intimidating. This is why I recommend going to a local college and learning some fundamentals. Once you've gotten a handle on the basics, you can refer to the manual to expand your knowledge of the program.

WM: Also, I think Photoshop now comes with a CD that has a lot of tutorials the program can walk you through.

JE: A big improvement. Whenever I'm reading one of these manuals, my mind is screaming "just show me, just show me." That's where the CDs come in handy. They show you how to use some of the basic tools. Another way to learn a program is to buy training tapes.

WM: I tried some of the MacAcademy tapes and thought they were very helpful.

JE: I think that they're very helpful too. Fractal also offers a couple of tapes on Painter and one on Ray Dream.

WM: So Fractal Painter and Photoshop are probably the real workhorses for you. And I know you talked about doing some things in Ray Dream. Can you quickly take me through the process of a typical assignment and how you would do it?

JE: Let's say the assignment was to paint a still life. I would initially try and find props to photograph, for example, a mirror, hair brush or some flowers, something that I could capture in the studio, turn into a slide and scan into the computer and I would use that as reference. I often shoot the elements separately, scan them in and create the composition

in the computer. This frees me from getting locked into a composition at the photography stage.

WM: You would be layering in Photoshop at this point?

JE: Yes. I arrange the composition in Photoshop, and adjust the colors and values. Depending on the job, it would be at this stage that I might take the composition to Painter. If Photoshop's strength is in its editing power, Painter's strength lies in its creative tools. It's common for me to use two or three programs to create a piece of art and generally speaking, these programs are written to be inter-compatible.

WM: How long did it take you to feel comfortable doing a job using a number of different software applications? Was that very difficult initially?

JE: That kind of grew naturally. The first program I learned was Photoshop. I learned it inside and out before I started using other applications. As I became aware of what some of the other programs were capable of, I made an effort to learn them as the need arose. An example would be Adobe Illustrator. I don't use Illustrator much but I know it creates nice, clean shapes and when I'm doing something that requires a complicated shape, I'll go there to create the outline of a shape. I did an illustration of a parchment scroll and I created the outline of the scroll in Illustrator, then imported the Illustrator file into Photoshop and this became the basis for creating the scroll.

WM: So you created the basic structure in

"Love, Remember Me"

Illustrator, imported it into Photoshop, and began to add the tonality with Photoshop's tools...it's the same thing as if you were transferring a drawing onto a canvas.

JE: Good analogy.

WM: I think this is helpful for conventional illustrators to understand, that in essence you're really going through the same process and it's only the mystery of the electric plug that's baffling. Can you give me another example of working in multiple programs?

JE: Occasionally, when I can't find an important prop for reference, I turn to a 3-D program like Ray Dream Designer and create it there. I then bring the rendered image into Photoshop and incorporate it into the illustration.

WM: Tell me a couple of things about the technical aspect of the computer that you find difficult.

JE: Besides reading the manuals, I find it a chore to maintain the computer.

WM: Do you have a computer guru at your beck and call?

JE: I do. You need someone like this to get you started, and when things go wrong. And things do go wrong.

WM: Is this expensive?

JE: Everything about the computer is expensive. Buying it, maintaining it, upgrading programs and equipment. I know this is a huge commitment and the costs seem astronomical, but the computer has helped me to become a lot more productive and as a result I am able to justify some of the costs that are associated with it.

WM: Does this mean you are working faster?

JE: Yes, much faster. I often take the time savings and channel it back into more creative solutions. As I was saying before, this is how I am able to create several solutions for the same assignment.

WM: It's quite evident that you've made quantum leaps in what you've been doing as an artist. That could be intimidating for a lot of conventional artists.

JE: But I am a conventional artist, I'm from the old school.

WM: That's what's going to be unique about this book. This will be the first book written by a conventional illustrator with a realistic painting style, who has gone digital.

JE: Pixel painting is in its infancy and there's a tremendous opportunity here for traditional artists to use this medium and help shape its future.

WM: A new generation of computers seem to evolve every few months. This can be daunting for the novice. If I buy this computer, is it going to be worthless in a year?

JE: The computer you purchase tomorrow will be usable for years to come. Just because the company comes out with a better model doesn't mean that the one you're using is outdated or useless.

WM: Have you made any major changes to your studio?

JE: My studio was designed with lots of natural light for canvas painting. The first thing I do in the morning now is close the shades. I work in as dim a light setting as possible to avoid monitor glare.

WM: What kind of monitor are you using? What size?

JE: I'm using a 20-inch Multiscan monitor.

WM: We know there's a substantial increase in price from a 17-inch monitor to a 20 or 21 inch. Did you start out with a 17-inch monitor?

JE: No I started out with a 20.

WM: Would you suggest going to the largest possible monitor? And is there a big difference between what you see on the monitor and the printed piece?

JE: There can be a difference, and it is a problem that requires some adjusting. I have an Iris print made of my work and adjust the monitor to match the output.

WM: I know from my experience as a conventional painter to always paint my skin tones about 10% lighter because red always runs up in the reproduction. So you can now anticipate these problems and instantly adjust for any vagaries in the printing process right up front.

JE: With enough practice.

WM: I would bet you're much happier with your reproductions now that the transparency stage is bypassed.

JE: Going to a transparency is a loss process. Information is lost due to the color balance and limitation of the film. Especially in colors like aqua green and red. I am thrilled, as are a lot of my clients, with some of the colors we are now able to achieve.

WM: So that is a big advantage.

JE: Traditionally made illustrations are converted to pixels at the prepress stage anyway, either by separations made from transparency, or drum scanning art on flexible board. Creating the art in the digital format is an advantage.

WM: Traditional illustrations are generally created several times larger than the printed piece. Does this rule hold true with

digital illustration? What size do you work and how do you deliver your artwork to art directors?

JE: A digital illustration should be created the same size as its final output. When I am working, I usually zoom in to a particular area to see detail. I zoom out to screen size to view the entire piece, sort of like stepping back from the easel. When I'm done, I deliver the art on disk—usually Syquest or Zip, accompanied by an Iris print.

WM: How do store your images?

JE: I store them on writable CDs which currently hold 650MB. That's about 30 to 40 illustrations.

WM: Do you put those in safe storage off site in case of fire?

JE: I have a complete archival inventory off site. And think of the storage space I am saving upstairs in the attic.

WM: What about preliminaries? Are you still showing pencil sketches?

JE: No. Pencil sketches were a natural part of the traditional medium process. Making changes to an oil painting can be painful, so getting early approval helped avoid corrections. I look at each new assignment now as an opportunity for exploration and preliminaries can sometimes be limiting. Since correcting the work after the fact has become so much easier, I prefer to go right to finish.

WM: That's an unusual way of working for most conventional artists.

JE: It's unusual but it works.

WM: Many natural media artists would say "I learned how to paint and draw the hard way and dammit I want to continue doing it the hard way." Will these hard-earned drawing and painting skills be an asset to an illustrator gone digital?

JE: Yes, absolutely. It's like giving your brush steroids.

WM: How do you see illustration changing and what do you think is in store for us as we approach the new millennium?

JE: The illustration profession is in a state of flux. To many, including myself, we seem to be approaching an era of chaos. The rules are changing rapidly and oddly enough, being computer literate gives me a sense of security.

WM: How do you see the rules changing?

"Until You"

JE: I think the future of illustration is in problem solving. Your value as a creative person will be just as important as your skill with a brush.

WM: Illustrators have always been told that "You have to have one style, kid, or you will never get anywhere." Do you think this is changing?

JE: It is certainly changing for me.

WM: Somewhere down the road, all that we're talking about will be incorporated into the work process of a whole new generation. I think it's interesting that you have one foot in the future and one in the past that reaches back through the Golden Age of Illustration to the days of Howard Pyle.

JE: When we came of age, working in natural media was the only game in town. Working this way for so long helped develop a depth of understanding for me that can't be replicated. Our generation will be unique in this way.

Getting Started

Section Four

MAC OR PC

The first question you will need to answer is which kind of computer system (referred to as platform) you should choose—Apple or PC. My own experience here is limited to Apple Macintosh.

Apple has historically been a proprietary system, meaning that you couldn't use PC (sometimes referred to as IBM compatible) software. Walk into any Best Buy and you will see that there is a great deal more software written for PC than Mac. However, all the important software, and certainly all the software you will need, is currently available for the Macintosh.

For graphics professionals, Macintosh seems to be the favorite. All of my clients, and all but one of the digital artists I know use Macs. Service bureaus usually service both platforms, but those catering to the graphics industry are more Mac oriented.

If it seems that I am pointing you in the direction of buying a Mac, I am actually not. All I can do is offer you the benefit of my own limited experience. PCs are less expensive and there are plenty of graphics professionals out there using them. You will have to decide for yourself which platform is right for you!

You might also consider a Mac clone. Apple has licensed its technology to several computer companies including Power Computing, Umax, and Motorola, who are making Macintosh platform computers.

COMPUTER

If you can afford it, buy the fastest, most recent model you can get your hands on. Speed is measured in megahertz, but this is not the only determinant. The processing chip is also a factor and Apple's 604e is their fastest as of this writing. As recently as 1993, computers were only running at 30 MHz but speeds exceeding 200 MHz are now available. Also, if you've got lots of cash and plan on using Photoshop most of the time, consider a multi-processor model. This means two processing chips instead of one and offers significant performance improvements in computation intensive

Fig. 1. The author's primary workstation includes a PowerMac 8500, Syquest and Zip Drives, inkjet printer, 20 inch monitor, keyboard, mouse, graphics tablet, and UPS(uninterrupted power supply).

Fig. 1

applications (like Photoshop). This would be my choice.

Pre-owned, older models are cheaper but they are likely to be much slower than what is currently available. Also the manufacturer may not offer technical support over the phone and the newest software may not be backwards compatible. If you go this route, and if you buy a Macintosh, be sure it uses the newer DIMM technology for its RAM configuration. DIMM stands for Dual Inline Memory Module and it is how your RAM is configured for the computer. The changeover from the older SIMM technology was made soon after the introduction of 1994 PowerMac 8100/80.

Also, make sure your computer comes with a CD-ROM drive, 4X speed or better. If it doesn't, buy an external one. And while you're at it, pick up a pair of inexpensive computer speakers to enhance the sound.

KEYBOARD AND MOUSE

If your computer doesn't come with these you will need to buy them separately. You may opt to buy an extended keyboard which adds extra keys. This is handy but not essential.

Note: If you buy an Apple Computer, get an Apple keyboard, too. Third party keyboards can sometimes be a little buggy when you are working on a Mac.

MEMORY

Computers come with two kinds of memory, Random Access Memory (RAM) and Hard drive memory. Applications like Adobe Photoshop and Fractal Design Painter are pixel-based programs and if you are painting for reproduction, the files they create are huge. These files will make great demands on both RAM and hard drive storage capacity.

Consider your hard drive to be your filing cabinet. It is where you will store information like programs, letters, billing, just about anything you create on the computer including, of course, your artwork. Most computer manufacturers offer a choice of out of the box configurations with regard to hard drive memory. I recommend a minimum of 2 gigabytes (that's 2,000 megabytes!). Buying less will surely

Fig. 2.
A secondary workstation includes a PowerMac 8100, 20 inch monitor, slide and flatbed scanners, modem, keyboard, mouse and graphics tablet.

Fig. 2

111

trip you up later. More would be better. If you prefer, you could add another hard drive later down the road, either internally or externally, or you could do what I have done and purchase an Iomega Jaz drive, an add-on device which has one gigabyte removable disks. These pop in and out like floppy disks, but let you add memory to your setup as you need it.

RAM: This is active memory. It is the memory you will need to run the programs. Some vector (non-pixel) based programs like Adobe Illustrator and Macromedia Freehand and most word processing programs require very little RAM. Pixel-painters need lots of RAM.

The amount of RAM that comes with some computers, sometimes as little as 16 megabytes (MB), is barely enough to open Photoshop 4.0, let alone use it. Additional RAM comes in modules of 4MB, 8MB, 16MB, 32MB, or 64MB. If you are trying to keep costs down, I recommend you have your factory authorized reseller add two 32MB memory modules. This would be enough to get started. If you are able to buy more, get two 64MB modules instead.

An 8"x10" image with a resolution of 300 dots per inch (dpi) weighs in at about 25MB. This is a common resolution setting for images intended for professional printing. Using the layers option could easily boost this to 80MB. Software manufacturers recommend having three to fives times the file size in RAM. Two 64MB modules, along with the RAM that comes with your computer, should give you about 150MB total and this has proven to be sufficient for me.

Note: Remember to allot as much RAM as you can to the imaging program you are working in. With 150MB of RAM, I allotted 120MB to the application in use, leaving the rest of the memory for the system software.

MONITORS

The next most important component for your workstation is a color monitor. Twenty and twenty one inch monitors are ideal but expensive. And you will need to be sure you have enough VRAM (video RAM) to run millions of colors. Check with the reseller on this.

If cost is an overriding concern, you might consider a 17" monitor, especially a 17" monitor that swivels from landscape orientation (horizontal) to portrait (vertical). Macintosh computers allow you to use two monitors, so it would be possible to put your art on the 17" and buy an additional 13" monitor for your numerous palettes. This setup might require an added video card, so get some advice on this as well.

All components, including monitors, are constantly being improved and new models are introduced into the marketplace every day. Do some research. Read the computer magazines for product comparisons. PC Magazine, Macworld and MacUser are good publications to start with.

Note: If you buy a Macintosh computer and a non-Apple brand monitor, you will probably need a small adapter to hook it up.

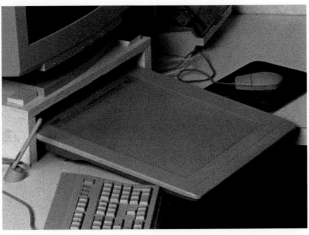

Fig. 8. The ARTZ II graphics tablet from Wacom Technologies.

Fig. 8

GRAPHICS TABLET

Although it is possible to paint using a mouse you would not find it very practical. Pressure sensitive graphics tablets, like the one pictured above, ship with a digital pen that allows a much more natural and familiar drawing experience. Still, it is a big change from working in natural media and will take a little getting used to.

WACOM Technologies Corp. seems to dominate this field on the Mac side and they make an excellent product. Offering more features than you will ever use, the out of the box configuration is all you really need. Truly "plug and play,"

buying this item should be a no-brainer. You will probably want the 12"x12" size, although the 6"x8" version might prove adequate and will surely be a lot cheaper.

PRINTER

The short answer to this very long question is to buy an inexpensive ink-jet printer for a few hundred dollars. You can print letters, labels, envelopes and even some preliminary proofs of your artwork. Apple, Canon and Epson are among the manufacturers who make excellent ink-jet printers, but do some homework here. This product improves greatly with each new generation and it is worth a little research.

Here is the long answer. These ink-jet printers may not be suitable for making quality prints of your work. For displaying your artwork or showing it to clients, dye-sublimation prints are an excellent choice. This technology is most like the continuous-tone quality you get from a photographic print. Dye-sublimation printers are very expensive, costing thousands of dollars. There are a few less expensive models that use your computer's engine to process the print, but unless you have the patience to stand by for half an hour while your printer commandeers your computer, this solution may not be practical. If you are not going to be making large volumes of prints, you might consider looking for a service bureau that can make dye-subs for you.

As much as I like the look of dye-sublimation prints, I have not found this technology to be a solution to pre-press proofing. If your artwork is intended for commercial printing, that is, offset lithography, you will want to know that the picture will print exactly the way you have created it. Industry people use the acronym WYSIWYG (pronounced wizzywig) to describe this problem. WYSIWYG stands for "what you see is what you get" and unfortunately, what you see on your screen is often not what you get when you go to press. Your monitor will need to be calibrated (adjusted) to match your output (printed piece).

The most reliable printer I have found for pre-press is a Scitex Iris printer. Scitex charges a king's ransom for one of these so you are most likely only to find one at a service

bureau. The prints themselves are expensive, costing around $40 each, but if you want to control the quality of the art through the printing stage send this proof along with your digital artwork and ask the printer to match it.

My solution to the WYSIWYG problem was to adjust the colors and values of my monitor to match the Iris print using the Gamma control panel that comes with Photoshop. This has worked for me in most cases.

SCANNERS

A flat-bed scanner is not an essential item but it is convenient at times. Look for an entry level (inexpensive) model for under a thousand dollars that comes bundled with Adobe Photoshop, or Adobe Photoshop LE. The latter is not the full version of Photoshop, but you can upgrade to the full version and save hundreds of dollars.

Don't opt for the slide attachment that some manufacturers offer. Instead buy a slide dedicated scanner. This will become your workhorse for inputting photo reference. Most models allow scanning from negatives as well. If you are working on a rush job, you could photograph with negative film, take it to a one-hour developer, and start scanning in your reference right away.

Slide scanners sell for under $2,000. Nikon and Polaroid are leaders in this area but again, do some research. If you are trying to save some money you might try to find a used one at a good price.

REMOVABLE MEDIA

Your computer will come with a floppy drive for inputting and removing information. The disks only hold 1.4MB of information so their use is limited. To put this in perspective, remember that an 8"x10" image file can be as much as 25MB. You will need a method of removing and transporting large files to clients, service bureaus, and offset printers.

For years, SyQuest Technologies dominated this market with $500 drives using 44 or 88MB portable disks each costing between $50 and $100. These had become the industry standard until Iomega took the market by storm with a $200

Zip drive and 100MB disks costing less than $20 each. These Zip drives are a big success and are fast becoming the current favorite.

These devices require that the receiving party has the same type drive. Most service bureaus have both. Check with your clients and colleagues to see what they are using before you decide.

ARCHIVING

At some point even your multi-gigabyte hard drive is going to get over-stuffed with image files. When this happens, and it may be some time before it does, you will have to look into a long-term solution for storing your digital artwork. If your finished image files are 20MB each you can guess how long you have got until the crunch comes.

My choice was a CD-ROM writer. Every so often I transfer my finished images onto writable CDs for archiving. This media is very durable, each capable of holding 650MB of data. And at eight dollars per disk, very affordable. The CD writer itself is a peripheral device that at this writing sells for under $1,000. Lots of manufacturers are making these, so do your homework.

The bad news about CD-Rs is that they are a write-once technology. Once you burn the information onto the CD it's permanent and can't be overwritten. If this doesn't fit your needs, you might consider an optical drive or DAT (digital audio tape). Both are rewritable media.

MODEMS

This an item you might consider putting off for a while. You will have enough to learn with just your computer and a few programs. You have lived this long without cruising the Internet, you can hold off for a few more months.

Aside from enabling your computer to access the Internet and the World Wide Web, your modem is capable of connecting directly to another personal computer over the phone line. Although you can pass files, including image files, to another party this way, it's a real headache setting it up. A much easier way to pass a file to a client, say a preliminary

sketch or a preview of the finish, is by attaching the image to your E-mail and dropping it in your client's electronic mailbox. They can pick it up at their leisure, assuming that they have an Internet address. You would need to set up an Internet account for yourself with an access provider like Compuserve, or America Online, a local provider or even AT&T. America Online (AOL), in particular, is an excellent way to transfer low resolution image files over the modem, as long as the recipient has an AOL account as well.

Relative to other components, modems are inexpensive. Buy a fast one with 28.8 bps.

MISCELLANEOUS HARDWARE

Be sure to use surge protectors. Not the $15 kind found at home centers but the $50 kind found at computer stores.

At some point you might want to take this a step further and purchase an Uninterruptable Power Supply unit. Costing a couple of hundred dollars, this device guarantees a stable, unfluxuating supply of electric current. If your power shuts off, this unit will keep your computer running long enough to save the file you're working on and shut down. It also suppresses power spikes which can damage your system.

Some of your external components like scanners and SyQuest drives are Small Computer System Interface devices referred to by their acronym SCSI (pronounced scuzzy). There is only one port on a PowerMac to attach these devices so they are connected to each other through a daisy chain configuration. It is important that these devices all have correct "addresses" and that the chain be terminated properly. This is one of the few areas where you can really do some damage so get some good advice on arranging this portion of your system. And if you need to buy extra cables get thick, well-insulated ones. Apple and APS Technologies make great cables.

SOFTWARE

The biggest investment you will make in software is not money but time. These programs are powerful, which means that they have loads of features and capabilities to help you

make art. The complexity that this brings causes these programs to have steep learning curves and the time you invest will be substantial, so it is important to pick the software that is right for you.

Adobe Photoshop is perhaps the most popular of the imaging applications. It is relatively easy to learn, cutting edge and powerful. This was the first program that I learned and I worked with it extensively before branching out to other applications. It is a good place to start because its interface, which may seem overwhelming at first, is actually very intuitive and logical. There are other choices out there besides Photoshop you could consider, among them XRes, and Live Picture.

Fractal Painter's forte is in providing brush capabilities that closely mimic real-life natural media like watercolor, pastel, charcoal, etc. Its other many powerful features make this a must-have. Although Painter and Photoshop share many common features, like layers and masking, they complement each other well. Lots of people use both.

Your computer's capabilities of course go beyond just making pictures. You will need a word-processing program for letter writing, billing, etc. ClarisWorks is a good choice for this category.

This is enough for your first purchase. As you become more familiar with these programs, you might consider adding some third-party plug-ins for Photoshop and Painter. Among them Kai's Power Tools, and XAOS's Paint Alchemy. There are other programs you might look into down the road. An object-oriented drawing program like Adobe Illustrator or Macromedia's Freehand. Metatools, now merged with Fractal Design Corp., makes a great 3-D landscape program called Bryce. Three-D programs like Ray Dream Designer and Infini-D specialize in creating objects that can be rendered and brought into your 2-D paint program. These 3-D applications are particularly hard to learn for a beginner and I suggest you get your feet wet first with a 2-D paint program.

Remember that each program you buy carries with it a substantial learning curve, so don't rush into purchasing everything at once.

HOW AND WHERE TO BUY

If I haven't mentioned it before, find yourself a computer guru—a consultant who can help you purchase, set up and troubleshoot your system. If this person can help you get started learning your graphics programs, and be available when something goes wrong, you've struck gold. Speaking of gold, expect to pay this person $50 to $100 an hour!

Local retailers sometimes offer to hold your hand through the whole process of getting started. Don't count on this. They are far more interested in the next purchaser coming through the door. Computer warehouses offer substantial discounts off local retailer prices, but little else. No hand holding here either. A third option you might consider is mail order.

There are several mail order companies that you can rely on to be very helpful in purchasing what you need. Their prices are as good or better than warehouse and for a reasonable shipping charge you can often have it the next day. Many will offer some basic tech support. Tell them this is your first computer purchase and consider buying everything from the same reseller if possible. Prices won't vary much from one to the other, but it doesn't hurt to check. I have purchased from PC/MAC Connection, MacMall, MacZone, MacWAREHOUSE and PrePRESS DIRECT, with complete satisfaction. Check and see what their return policy is. If the product is bad out of the box, you want a new one from *them*, not the manufacturer. The manufacturer could force you to take a rebuilt component as a replacement.

If the service bureau you will be working with, the one that will be providing you with printing and other output services, also happens to be a reseller, then this may be another good buying source, providing their prices are competitive. You can get helpful advice from a supplier that you work with often.

Finally, if you are a student, schools can sometimes get a substantial discount for you, so don't overlook this option.

HOW AND WHERE TO LEARN

As I have mentioned earlier, you will be absorbing gallons of information. How to set up and run your computer, maintain it, troubleshoot problems and run the programs you will need to make art. By now you will have realized that going digital is costly, but be sure to leave room in your budget for education.

Start with the computer itself. Most local colleges offer night classes in introduction to Macintosh or introduction to the PC. Most will offer basic Photoshop courses as well, and this is a good way to begin. If your local school doesn't offer courses in Painter or some of the more specialized programs you want to learn, try an art school if there is one nearby.

Of course, private instruction is also a great way to learn, but expensive. Again, hopefully you will have a guru to turn to for this.

And when you start having problems with your computer, and you will, you will want a consultant to come in and straighten things out. Take this opportunity to learn all you can about your computer so you can do this maintenance yourself!

Another great way to learn is by video training tapes. MacAcademy sells training tapes for most of the popular programs. These tapes are pricey at $50 each but learning this way can shorten the learning curve considerably. Fractal Corp. sells a few tapes for Painter and Ray Dream, which are excellent and much more reasonably priced.

All of these suggestions will help to get you started and move you along through your first year or so. Experience is the best teacher, and most of what you will learn will come by doing.

MY EQUIPMENT LIST

The list of hardware I am currently using is listed below for reference only and is not necessarily an endorsement of these products. I am sure by the time you read this that this list of components will be hopelessly outdated and I don't recommend that you try to duplicate it. Do your own research—there are always new and better products coming onto the market everyday.

Also, as it happens, I use two workstations. This is a luxury and something to grow into if the need arises. I use the older 8100 station for scanning, and rendering files from raytracing programs like Bryce and Ray Dream, so that these time consuming functions don't tie up my main workstation. I also share this computer with my wife who is a graphic designer. These two computers are connected via Ethernet 10BASE-T.

Primary workstation

PowerMac 8500

280MB RAM

2 Gigabyte hard drive

Apple Extended Keyboard and Mouse

Apple 20" Color Monitor

Apple Color Stylewriter Pro Printer

Wacom ArtZ Graphics Tablet and Stylus12x12

Syquest Drive

Iomega Zip Drive

Iomega Jaz Drive

APC UPS1400 (power back up)

Pinnacle Micro RCD 1000 CD-Writer

Gravis Joystick (Don't tell anybody)

Secondary Workstation

PowerMac 8100

80MB RAM

2 Gigabyte hard drive

Sony Multiscan 20" Monitor

MacALLY Keyboard and Mouse

Nikon Coolscan Slide Scanner

Umax UC630 Flatbed Scanner

Wacom Tablet and Stylus UD12x12

Global Village Teleport Platinum Modem

Showcase

Section Five

Daniel Pelavin
"Machine"

80 Varick Street #3B
New York, NY 10013
email:daniel@pelavin.com
web site:www.inch.com/~dpelavin
Hardware: Power Macintosh IIci
Software: Adobe Illustrator

Chris Spollen
"System Crash"

362 Cromwell Avenue
Ocean Breeze, NY 10305
email: CJSPOLLEN@aol
web site:
http://www.INCH.COM/~CSPOLLEN/
Hardware: Macintosh IIci
Software: Adobe Illustrator 5.5,
Adobe Illustrator Dimensions

Dennis Orlando
"Dock with colorful boats"

79 Brookline Road
Ivyland, PA 18974
email: dorlando@voicenet.com
website:
http://www.voicenet.com/~dorlando
Hardware: Macintosh IIci
Software: Fractal Design Painter

Donald Case
"The Love Within"

58 Round Lake Park Road
Monroe, NY 10950
email:76767.1521@compuserve.com
Hardware: Power Macintosh 8100/80
Software: Adobe Photoshop 3.0,
Fractal Design Painter 3.1

Judy York
"Renaissance"

500 East 83rd Street Apt. 2L
New York, NY 10028
Hardware: ALR Pentium PC
Software: Adobe Photoshop,
Fractal Design Painter

Michael Garland
"Angel plate"

19 Manor Road
Patterson, NY 12563
email: garlandmp@aol.com
Hardware: PowerMac 9500
Software: Adobe Photoshop

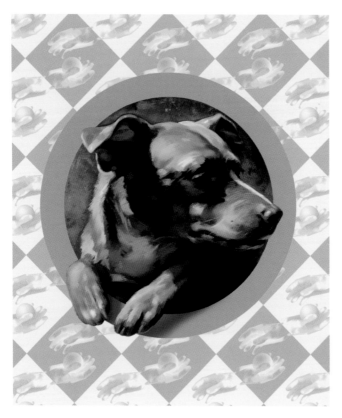

Nancy Stahl
"Dog"

email: NStahl@aol.com
Hardware: Power Macintosh
8500/120
Software: Adobe Photoshop,
Fractal Design Painter

Franco Accornero

620 Broadway
New York, NY 10012
Hardware: Power Macintosh 8100/80
Software: Adobe Photoshop

David Mattingly
"Animorphs #4: The Message"

1112 Bloomfield Street
Hoboken, NJ 07030
email: david@davidmattingly.com
web site: david@davidmattingly.com
Hardware: Power Macintosh 9500
Software: Avid Elastic Reality,
Adobe Photoshop

Jeff Brice
"Springhead"

email: Jeff Brice@aol.com
Hardware: Supermac Power Mac
Software: Adobe Photoshop,
Specular Collage

Don Arday
"Career Forecast"

616 Arbor Creek Drive
DeSoto, TX 75115
email: dar855@airmail.net
Hardware: Power Macintosh
Software: Macromedia Freehand 5.5,
Adobe Photoshop 3.0

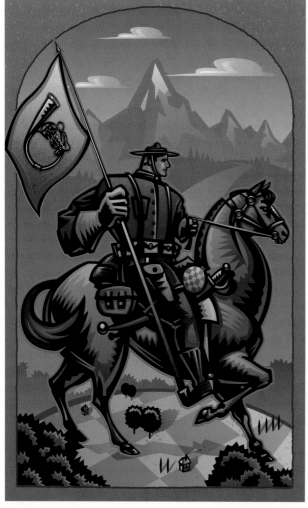

Mike Kasun
"Salute to Wagner"

301 N. Water Street 6th floor
Milwaukee, WI 53202
email: mkasun@execpc.com
Hardware: PowerMac 7100/80
Software: Adobe Illustrator

Ray Vella
"MTV"

20 N. Broadway
Building G. I-240
White Plains, NY 10601
914-997-1424
Hardware: Power Macintosh
Software: Macromedia Freehand 5.5
Adobe Photoshop 3.1

Joanie Schwarz
"An Angel Passed Over"

561 Bradford Avenue
Westfield, NJ 07090
Represented by Vicki Morgan
email: sukisart@ix.netcom.com
web site: http: www.spar.org
Hardware: PowerMac 8100
Software: Adobe Photoshop,
Fractal Design Painter

Glossary

application a software program

Boolean in 3-D drawing programs, Boolean operations refer to mathematical calculations that determine the union, intersection, and most frequently the subtraction of solid geometric objects.

CD-ROM (Compact Disc Read-Only Memory) stores data files that can be read from your computer, but not written over

dialogue box these pop open on your screen to access controls of the current function

DIMM (Dual In-line Memory Module) a small circuit board containing RAM. These cookie-size boards are plugged into slots inside your computer to increase memory

disk magnetic material on which data can be stored— spinning rapidly, a disk reads and writes information onto concentric tracks

dpi(or ppi) dots per inch (or pixels per inch) refers to how the resolution of your screen or output is measured

die-cut A printing term for a custom cut-out

dye sublimation a digital printing technology producing photographic-like prints

export to move a file to another program or printer

file a generic term for work created in a software program

filter a mini-software application that plugs into a host application (like Photoshop) and is used to affect the image

flatbed scanner peripheral device that reads flat art or an item and converts it into pixels

floating layer a feature of many graphics applications that allows art to be created and edited on separate layers

floppy drive a mechanism that reads a floppy disk

gigabyte two thousand megabytes

gradient gradual transition of tone or color

graphics tablet peripheral device used to simulate a natural drawing experience

hard drive a device used for data storage

import to move a file into your current application

Iris brand name of a printer made by Scitex Corp.

Jaz drive brand name for a large capacity removable disk technology

mask a graphics device used to protect part of the image

megabyte a unit of measure equaling 1024 kilobytes

megahertz a unit of measure generally referring to the speed of a computer

pixel a contraction of the phrase picture element, one of thousands of square dots that make up the computer screen

platform type of computer, usually referring to Macintosh or PC

plug-in a mini application that plugs into a host application

processing chip the tiny silicon circuit board that does all the work

RAM Acronym for random access memory, the memory that runs the applications

raytracing a mode of photorealistic rendering that calculates the path of imaginary rays of light from the observer's viewpoint to a 3-D object. The color of each pixel is determined by how these rays would bounce off, pass through, or be absorbed by the object's surface.

removable media usually disks that store information and can be removed from the computer. Floppy, Syquest, Zip, Jaz, and CD are all removable media

rubylith a material used in the graphics industry for masking

scan to convert into pixel form

service bureau small companies that service the digital graphics industry

SIMM Single In-line Memory Module, an older RAM technology replaced by DIMM

stepback a paperback book publishing term referring to art tipped into the book just beneath the front cover

stylus a digital pen used in conjunction with a graphics tablet

Syquest drive brand name for a removable media technology

UPS uninterruptable power supply

virtual existing within the digital realm only

VRAM Video RAM, memory used to support a color monitor

wireframe a preliminary visualization of a 3-D object

ZIP drive brand name of a removable media technology

Resources

HARDWARE

Apple Computer, Inc.
1 Infinite Loop
Cupertino, CA 95014
408-996-1010
800-554-3848

Global Village
Communication, Inc.
1144 East Arques Avenue
Sunnyvale, CA 94086
408-523-1050
Fax/modem

Iomega Corp.
1821 West Iomega Way
Roy, UT 84067
888-2IOMEGA
Zip drive
Jaz drive

IRIS Graphics
Six Crosby Drive
Bedford, MA 01730
617-275-8777
IRIS printers

Nikon Inc.
Electronic Imaging Dept..
1300 Walt Whitman Road
Melville, NY 11747-3064
516-547-4355
Coolscan 35mm
film scanner

Polaroid
575 Technology Square
Cambridge, MA 02139
800-816-2611
617-386-2000
35mm film scanner

Power Computing Corp.
2555 North IH 35
Round Rock, TX 78664
800-410-7693
Mac clones

UMAX Technologies
47470 Seabridge Drive
Fremont, CA 94538
800-546-8557
color scanner (flatbed)
Mac clones

Wacom Technology Corp.
501 SE Columbia Shores Blvd.,
Suite 300
Vancouver, WA 98661
360-750-8882
graphics tablet

SOFTWARE

Adobe Systems Inc.
1585 Charleston Road
PO Box 7900
Mountain View, CA 94039
800-833-6687
Adobe Dimensions
Adobe Gallery Effects
Adobe Illustrator
Adobe Photoshop

Alien Skin Software
2522 Clark Avenue
Raleigh, NC 27607
919-832-4124
**The Black Box
(Photoshop filters)**

Andromeda Software Inc.
699 Hampshire Road
Suite 109
Westlake Village,CA 91361
805-379-4109
(Photoshop filters)

Claris Corp.
5201 Patrick Henry Drive
Santa Clara, CA 95052
800-325-2747
ClarisWorks

Fractal Design Corporation
PO Box 2380
Aptos, CA 95001-2380
408-688-8800
**Painter
Ray Dream Designer
Detailer
Expressions**

Macromedia Inc.
600 Townsend Street
San Francisco, CA 94103
800-288-8797
**Freehand
XRES**

MetaTools, Inc.
6303 Carpinteria Avenue
Carpinteria, CA 93013
805-566-6200
**Bryce
Kai's Power Tools**

Specular International
7 Pomeroy Lane
Amherst, MA 01002
413-253-3100
1-800-433-SPEC
Infini-D

Fortune Hill, Inc.
606-269-0933 (phone)
606-268-2724 (fax)
www.fortunehill.com
email: samoore@best.com
**WildRiverSSK
(Photoshop filter)**

XAOS Tools, Inc.
600 Townsend Street,
Suite 270E
San Francisco, CA 94103
415-487-7000
**Paint Alchemy
(Photshop filter)**

EDUCATION

MacAcademy
477 South Nova Road
Ormond Beach, FL 32174
800-527-1914
training videos

BOOKS

Peachpit Press, Inc.
2414 Sixth Street
Berkeley, CA 94710
510-548-4393
The Little Mac Book
Visual Quickstart Guides:
 Painter for Macintosh
 Photoshop for Macintosh
The Painter Wow! Book
The Photoshop Wow! Book

Addison-Wesley Publishing
One Jacob Way
Reading, MA 01867
The KPT Bryce Book

MAGAZINES & NEWSLETTERS

Artistry
P.O. Box 8895
Calabasas, CA 91372-8895
818-878-0853

Computer Artist
Circulation Dept.
P.O. Box 3188
Tulsa, OK 74101

MacADDICT
Imagine Publishing Inc.
150 North Hill Drive
Brisbane, CA 94005
415-468-4869

Macworld
Macworld Communications Inc.
501 Second Street
San Francisco, CA 94107
800-288-6848
303-604-1465

MacUser
Ziff-Davis Publishing Company
950 Tower Lane, 18th floor
Foster City, CA 94404
415-378-5600

PC Magazine
Ziff-Davis Publishing Co.
One Park Avenue
New York, NY 10016
212-503-3500

Print
104 Fifth Avenue
New York, NY 10011
212-463-0600

Step-By-Step Electronic Design
Dynamic Graphics
6000 N. Forest Park Drive
Peoria, IL 61614-3592
309-688-2300

MAIL ORDER

APS Technologies
800-862-6805

MacMall
800-222-2808

MacWAREHOUSE
800-255-6227

MacConnection
800-800-1111

MacZone
800-248-0800

PrePRESS DIRECT!
800-443-6600

PHOTOGRAPHY STUDIOS

Fotographica
112 Fourth Ave.
New York, NY 10003
212-475-0111

Robert Osonitsch
112 Fourth Ave.
New York, NY 10003
212-533-1920

SERVICE BUREAUS

Bucks County Type & Design
832 Town Center Drive
Langhorne, PA 19047
215-757-3600

Color Group
168 Saw Mill River Road
Hawthorne, NY 10532
914-769-8484

Cone Editions Press
Powder Spring Road
East Topsham, VT 05076
802-439-5751

Digital Arts & Graphics
P.O. Box 8678
Princeton, NJ 08543
609-452-6446

The Digital Pond
50 Minna Street
San Francisco, CA 94105
415-882-9961

Duggal Color Projects
9 W. 20th Street
New York, NY 10011
212-242-7000

Jellybean Studio
99 Madison Ave.
New York, NY 10016
212-545-0986

MidCity Camera
1316 Walnut Street
Philadelphia, PA
215-735-2522

Paris Photo Lab
Los Angeles, CA
310-204-0500

Today's Graphics
Philadelphia, PA
215-567-0332

MAC GURUS

Matthew Gross
Westchester County, NY
914-232-6549

Terry Sanders
New York City
212-980-1893
(Graphic artist)

Jim Yost
Philadelphia
215-546-3052
(Graphic artist)

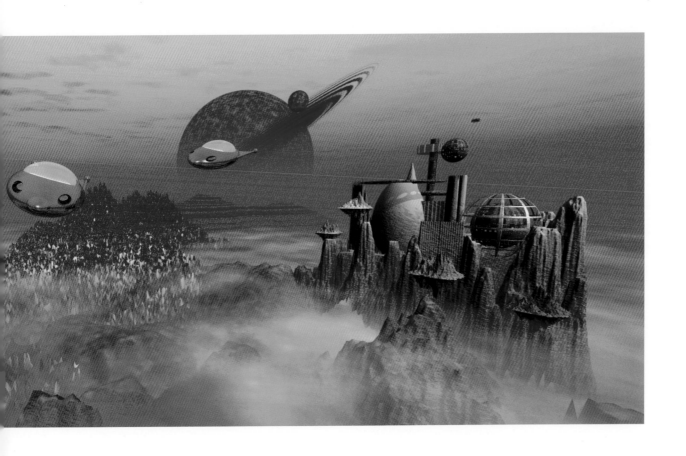